KEY

🚌 Bus stop ⏻ Underground 🅿 Parking 🇹 Tram

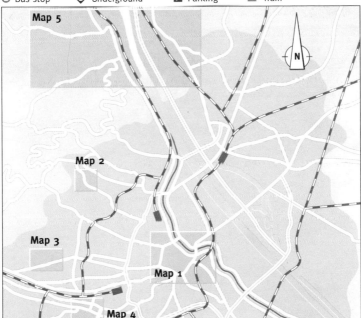

Map 5

N

Map 2

Map 3

Map 1

Map 4

First North American Edition

ISBN 0-8212-2232-5

Library of Congress Catalog Card Number
95–76698

Bulfinch Press is an imprint and trademark
of Little, Brown and Company (Inc.)
Published simultaneously in Canada by
Little, Brown & Company (Canada) Limited

PRINTED IN SPAIN

ART IN *focus*

VIENNA

Caroline Bugler

A Bulfinch Press Book
Little, Brown and Company
Boston • New York • Toronto • London

Contents

Contents

No visitor to Vienna can fail to be struck by the visible remains of past Imperial grandeur. Today the city may be the capital of a relatively small country, but it was once the centre of an Empire which ruled the lives of fifty million, and the Habsburg dynasty and their courtly entourage, who dominated Vienna for six and a half centuries, had an overwhelming impact on the city's architecture and artistic life. The Imperial family's winter and summer residences, the Hofburg and Schloss Schönbrunn, are important tourist attractions, and the city's chief museums – the Kunsthistorisches Museum, the jewels, silverware and weapons collections in the Hofburg, the Österreichische Galerie at the Belvedere and the Museum of Modern Art at the Liechtenstein Palace – were all formed around collections assembled by royal or aristocratic connoisseurs. They still reflect the personal tastes and idiosyncrasies of their founders. The Kunsthistorisches Museum, for example, housed in the splendid building created for it at the request of Emperor Franz Joseph towards the end of the nineteenth century, was originally intended to be linked to the Imperial residence of the Hofburg just across the road. Although a number of acquisitions have been made since the Habsburgs fell from power, the collection was never gathered together in a systematic way to present a balanced overview of art history in the way that most major national galleries in Europe and the USA do. Instead it retains the character of the private princely collection shown in David Teniers the Younger's painting of the Archduke Leopold Wilhelm: the works shown there are precisely the ones hanging on the walls of the museum today (1). Similarly, it was

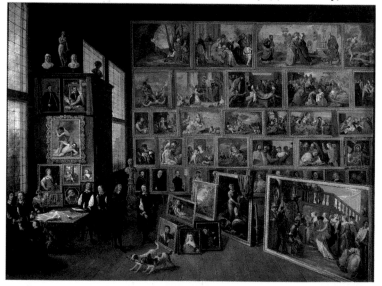

1. D. TENIERS THE YOUNGER, *THE ARCHDUKE LEOPOLD WILHELM IN HIS GALLERY AT BRUSSELS*, 1653 (KUNSTHISTORISCHES)

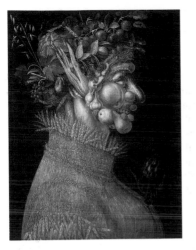

2. G. Arcimboldo, *Summer*, 1563
(Kunsthistorisches)

Emperor Maximilian II rather than a professional curator who was responsible for commissioning the series of fantastic heads by Giuseppe Arcimboldo which are one of the museum's star attractions (2).

Private patronage remains a prime source of the city's artistic treasures, although it has been supplemented by state initiatives. An important private collection with superb paintings from the turn of the century – the Sammlung Leopold – has recently been acquired for the city. It is most likely that it will be housed in the new 'Museums Quartier' to be developed in the old Messepalast in the square bordered by the Kunsthistorisches Museum and the Natural History Museum. Work has yet to start on this large new development, but it is likely that it will contain some of the city's temporarily housed collections, such as the Museum of Modern Art, as well as its currently homeless ones. The government's recent decision to furnish museums with generous grants for refurbishment has given rise to extensive restoration work which is likely to continue through the 1990s. Although the long-term effect will be excellent, as museums and palaces are restored to their former glory, it does mean that for the foreseeable future certain galleries or rooms in museums may be liable to closure. Some will also open up. At the time of writing, for example, the Schottenstift was about to reopen its gallery containing medieval paintings and objects.

Vienna also abounds in small museums and memorials – a clock museum, a clown museum, a tobacco museum and even a museum of undertaking which clearly reflects the Viennese obsession with death. Several are dedicated to musicians – there are three Beethoven museums, a Haydn Museum, a Mozart Museum, two Schubert Museums and Strauss Memorial Rooms . Because they are primarily of historical rather than artistic interest they fall outside the scope of this guide, and they are almost without exception rather disappointingly laid out, with little attempt to recreate their interiors in period style.

Quite apart from its fabulous art collections, the city itself is almost like an open air museum of architectural styles. The ensemble of lovely buildings is best enjoyed on a leisurely stroll through the mostly pedestrianized inner city, with frequent breaks for coffee and cakes. In many ways Vienna seems to be the quintessential Baroque city. Everywhere you look there are

Herculean caryatids supporting balconies, exuberant stuccowork flourishes, imposing marble staircases and wrought-iron arabesques. But beneath the pastel facades the city's earlier history is still visible in certain places. Roman buildings have been excavated under the Hoher Markt in the oldest part of Vienna. The Romans first built the fortifications to enclose the city of Vindobona, which they had taken over from a Celtic tribe named the Vendi, at the end of the first century AD. Although Roman rule ended in the fourth century, and Vienna was subject to repeated barbarian invasions and annexations, the Roman walls remained intact until the twelfth century, after which time the city developed outwards in a series of concentric circles until it reached the area now occupied by the Ringstrasse. The city's most ancient church, the Ruprechtskirche, which legend says was founded in 740, still stands in its own square. The Stephansdom (page 122) was first consecrated in 1137, and although the main body of the present building is Gothic, remnants of the thirteenth-century Romanesque building can still be seen in the west front, with its two 'Heathen' Towers and Giants' Gateway. The nucleus of the Hofburg (page 56), centred on the area known as Am Hof, was begun in the mid thirteenth century when the Bohemian Duke of Austria built his castle there. From that time on it was to provide a residence for the rulers of Vienna and the Austrian Empire, who after 1283 were members of the Habsburg dynasty

The fourteenth century saw the completion of the old city, whose street layout can still be detected in the narrow irregular alleys in the area behind the Cathedral. It was then, too, that the Gothic choir of the Stephansdom was built and that the lovely church of Maria am Gestade (page 104) and the Augustinerkirche next to the Hofburg (page 25) were erected. The city became the centre of the Holy Roman Empire – a community of German states. The material remains of this role can be seen in the Treasuries in the Hofburg (page 58), where the coronation robes and other Imperial regalia have been carefully preserved. Vienna was seen as the most easterly bastion of Western Christian civilization against the Oriental infidels, and from the fifteenth century to the end of the seventeenth the city was under repeated threat from the Turks. The fact that there are relatively few Renaissance buildings in Vienna is in part because so many of the city's financial resources had to be diverted into building a new set of fortified walls, which were completed in 1560. Outside the walls lay an area of flat land known as the *glacis*, upon which no building was allowed, and beyond that suburbs started to develop, mainly inhabited by crafts- and tradespeople.

It was not until the Turkish threat receded after the second siege of 1683 that the Habsburgs chose Vienna out of all the cities in their dominions as their court, administrative centre and capital, and it was at this point that the identification of the dynasty with the city was firmly established. Whereas previously the town had been dominated by middle-class burghers and merchants, now bureaucrats and aristocrats connected with Church and court came to prominence. The Jesuits had started the relentless process of converting a largely Protestant city back to Catholicism in the mid sixteenth century when they were invited to do so by Archduke Ferdinand, and the process, which was not without violence and coercion, lasted almost a century. A spate of church building began, during which

VIENNESE BAROQUE AND ROCOCO PAINTING

The spate of building that took place in Vienna after the lifting of the Turkish seige in 1683 meant a series of important commissions for the city's painters, both from patrons who wanted entire decorative schemes (often glorifying themselves) for their new palaces, and from the Church, which needed altarpieces and ceiling frescoes. The style of painting that evolved was designed to fill large spaces. Although sketches and oil paintings by Austria's foremost Baroque artists are on show in Vienna's public collections – notably in the Baroque Museum, the Historical Museum and the Akademie – they never quite convey the effect of the decorative schemes in situ, where the deployment of illusionistic perspective on a vast scale, of dynamic movement and brilliant colour can be breathtaking.

One of the first artists to excel in the genre was Johann Michael Rottmayr, whose masterpiece is the exuberant cupola in the Karlskirche depicting the apotheosis of St. Charles Borromeo borne up in a swirl of cloud and cherubs (3). His ceilings for the Liechtenstein Palace, where the Museum of Modern Art is currently housed, can also be admired as a counterfoil to the very different items on show below them. One of the city's greatest Baroque ceilings – that of the Prunksaal in the National Library – was created by Daniel Gran, who was sent to study in Italy by his patron Prince Schwarzenberg (page 60). Gran was also responsible for the frescoes in the stupendous Marble Hall at Klosterneuburg. Paul Troger and Martino Altomonte also painted several Viennese ceilings. Franz Anton Maulbertsch was the star of a slightly later generation; his frescoes in the Piaristenkirche, although in a sorry state of repair, are a colourful Rococo masterpiece.

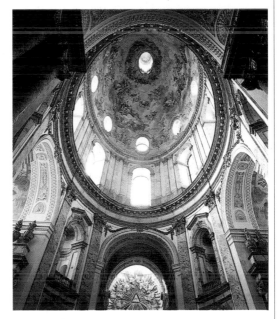

3. DOME OF THE KARLSKIRCHE

the city's greatest religious monuments appeared. Several existing Gothic churches were 'Baroquized' and given new interiors at this time.

In the late sixteenth century a host of Italian architects had come to Vienna, bringing with them the latest Baroque styles, but it was two native Austrian architects – Johann Bernard Fischer von Erlach and Johann Lukas von Hildebrandt – who made the most outstanding contribution to the capital, helping to fulfil Habsburg ambitions to create a city that would rival the building programmes of the French King Louis XIV. Having worked for the Archbishop of Salzburg, Fischer von Erlach was summoned to Vienna to create the Karlskirche (page 62) as a thanksgiving for the city's delivery from plague. This extraordinary masterpiece, whose white exterior gives way to an exuberant interior, was completed after the architect's death by his son Johann Emmanuel. Johann Bernard was also responsible for designing the Bohemian Chancery and the Winter Palace of Prince Eugene (4); for altering the Lobkowitz Palace; and for planning the Schönbrunn (although this was completed in a slightly different style by Nikolaus Pacassi), the exterior of the Schwarzenberg Palace and the Trautsoner Palace, and Joseph I's new domed library (page 60). Fischer's style was certainly Italianate – he was often referred to (inaccurately) as a pupil of Bernini. His rival, Hildebrandt, had studied in Italy before he came to Vienna. He worked largely for the nobility, unlike Fischer von Erlach, who received more court commissions, and his lighter and more ornamental style reached its apotheosis in the Belvedere (pages 27 and 35). In the Peterskirche just off the Graben he provided a successful solution to fitting an oval-plan church into a restricted site (page 116).

At this time bourgeois houses were given decorative flourishes in emulation of aristocratic dwellings. A stroll up Kurrentgasse in the inner city reveals a series of pastel-coloured facades enlivened with occasional bay windows, arches, pediments and other embellishments. The most lavish decoration can be seen in a house in Annagasse, just off Karntnerstrasse, on a house called *Zum Blauern Karpfen* (The Blue Carp), where a carp sits in a cartouche between two first-floor windows above a frieze of cherubs (5). This ornamental cornucopia did not necessarily indicate great wealth

4. STAIRCASE OF PRINCE EUGENE'S WINTER PALACE

5. FACADE OF THE HOUSE OF THE BLUE CARP

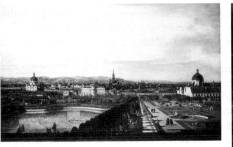

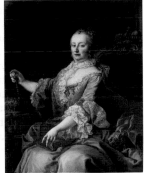

6 AND 7. (ABOVE) B. BELLOTTO, *VIENNA FROM THE BELVEDERE*, 1758/61 (KUNSTHISTORISCHES); (RIGHT) MARTIN VAN MEYTENS, *PORTRAIT OF THE EMPRESS MARIA THERESIA*, 1759 (AKADEMIE)

on the part of the occupants: many of such houses were subdivided into apartments, providing homes for five or six families, each of whom might have had a floor for their use. Tailors or shoemakers were often accommodated under the same roof as high-ranking civil servants or ministers of state. The Figaro Haus, where Mozart is said to have lived while composing *The Marriage of Figaro*, is a good example of this type of dwelling.

In the overcrowded conditions of the inner city decorative elaboration had to be modified to fit a confined space. Outside the city limits, where members of the aristocracy were building their summer palaces, the Viennese architects had greater scope for drama. At the beginning of the eighteenth century there were about 200 of these mansions, but most of them have now been swallowed up into the city's boundaries. The best-known examples of these seasonal retreats which the public can visit are Prince Eugene's twin palaces at the Belvedere (6); the Liechtenstein Palace (page 112); and Schönborn Palace which houses the Austrian Museum of Folklore (page 114). However, the summer palace that outdoes every other in sheer scale and magnificence is the Schönbrunn (page 118). Although it was begun at the end of the seventeenth century it owes its present appearance to the absolutist Empress Maria Theresia (7), who brought her favourite architect, Nikolaus Pacassi, in to finish the job that Fischer von Erlach had begun half a century earlier, adding Rococo flourishes to the stately Baroque structure.

The Baroque style continued to prevail in art and architecture in Vienna well into the second half of the eighteenth century, and it was never entirely displaced by the fashion for Neoclassicism, although there are some notable works in this genre, Kornhausel's Synagogue in the oldest part of town being an architectural example. The city also possesses two outstanding Neoclassical sculptures: Canova's monument to Princess Maria Christine in the Augustinerkirche (page 25) and his Theseus statue at the top of the staircase in the Kunsthistorisches Museum (page 68).

The Biedermeier style, which was most fashionable in the decades between the end of the Napoleonic Wars in 1815 and the year of Revolutions in 1848, presents an altogether more modest face. Decidedly unaristocratic in appeal, it was a style of building, furnishing and painting created for the kind of middle-class man personified by the fictional character who lent his name to it. Gottlieb Biedermeier was the comic creation of two German poets; and what purported to be his verses appeared in the

pages of a satirical review. He was a smug but honest petit-bourgeois, and Biedermeier style came to denote paintings that were homely, family-orientated, cosy and yet high-minded. This was the type of canvas perfected by Ferdinand Georg Waldmüller in the early part of his career (8), and by Friedrich von Amerling (page 37). The small-scale, unambitious subject matter with an emphasis on portraiture and interiors reflected a retreat into comfortable domesticity on the part of a middle class effectively excluded from political power and with limited civil rights, who diverted their energy into musical evenings or waltzing. In architecture Biedermeier

8. F. G. WALDMÜLLER, *SELF-PORTRAIT*, 1828 (ÖSTERREICHISCHE GALERIE)

style denoted simplicity – plain facades with small ornamental panels, and pleasing proportion. There are many such buildings in Vienna, but few of them belong to the inner city; to see them you have to walk through the streets of the older suburbs, such as Grinzing and Hietzing. The Geymüller-Schlössel on the outskirts at Pötzleinsdorf is a relatively exotic example of a summer villa of the epoch (page 51), fusing Gothic, East Indian and Arabian influences.

The cultural and domestic idyll of this era ended dramatically with the revolution of 1848, in which the new and impoverished industrial proletariat, faced with housing shortages and rising prices, joined forces with the dispossessed middle classes to demand reform. But the uprising was brutally suppressed and martial law proclaimed. In this unpromising atmosphere the eighteen-year-old Franz Joseph acceded to the Imperial throne. His reign was to last sixty-eight years and to see initiatives that changed the face of the city forever. Barely ten years after he became Emperor, Franz Joseph decided to order the demolition of the old fortifications, enabling the city to break through its straitjacket and join the suburbs beyond. In the green area in front of the former bastions, known as the *glacis*, a new wide boulevard known as the Ringstrasse was to be built. Proposals for creating a new complex were invited from architects in 1858, and by 1865 the polygonal Ringstrasse which followed the line of the ramparts was ready for use. Important municipal buildings were soon erected, with a pair of barracks placed at either end to deal with any possible insurrection. The first was the State Opera House, which opened in 1869 to the strains of *Don Giovanni*. This was followed by the new Houses of Parliament and a Town Hall, or Rathaus; twin museums for art and natural history; a Stock Exchange; a new University; and a number of luxurious private palaces. Some of the area of the former *glacis* became parkland, creating the broad belts of green that make Vienna such a pleasant and shady place to be in summer. The Stadtpark was laid out, straddling the canalized River Wien (now reduced to a pitiful trickle).

In 1879, while several of the buildings were still under construction, there was a grand procession along the Ringstrasse to celebrate the silver

The modernist architect Adolf Loos may have dismissed the Ringstrasse as 'Potemkin City' – a cardboard town hiding an essential emptiness behind its grandiose facades – yet there is a magnificence in the whole that derives from its confident and eclectic approach (9). Styles from several different ages were used for the different buildings, in keeping with the current taste for historical reference, and architects from all over Europe were invited to contribute to the development. The Dane Theophil Hansen looked to the architectural vocabulary of ancient Greece for his Parlament building, watched over by a gigantic statue of Pallas Athene. Next to it, the neo-Gothic Rathaus designed by Heinrich von Schmidt for Vienna's local government was inspired by the examples of Flemish cloth halls; no doubt he hoped that the developed sense of civic duty in the Low Countries might be an example to the Viennese. The Votivkirche nearby, designed by Heinrich Ferstel, took its inspiration from the French cathedrals of the thirteenth century – it was intended as a thanksgiving for the Emperor's escape from an attempted assassination. The same architect also designed the new University building, but this time he took the French town halls of the Renaissance as his model. Gottfried Semper and Karl von Hasenauer were responsible for some of the most lavish buildings of all: their new Burgtheater has a majestic dual staircase, with frescoes by the brothers Klimt and Franz Matsch, and other Baroque touches, while the Kunsthistorisches Museum and the Natural History Museum face each other across Maria Theresien Platz and are almost mirror images apart from their decorative details. Receptions for all these new buildings were mixed. The first one completed, the neo-Renaissance State Opera House, met with such scathing criticism – it was likened to a 'sunken box' because of its unfortunate low position in what had been the town ditch – that one of its two architects, Eduard van der Null, was driven to suicide. The last of the major buildings to be finished, the Burgtheater, had to close for refurbishment some nine years after its opening when it was discovered that several seats had no view of the stage and acoustics were abominable.

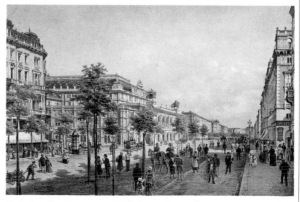

9. F. ALT, *THE OPERNRING*, 1890 (STADT MUSEUM)

wedding of Franz Joseph and Elisabeth. The man who designed the elaborate pageant was Hans Makart, Vienna's foremost society artist, and he rode at the head of the procession dressed in a Rubens costume. His pictures – often of historical or allegorical themes – were a painterly counterpart to the opulence and theatricality of Ringstrasse architecture (10). They also mirrored a taste in interior decoration for the overblown and cluttered which can be seen to perfection in the Hermesvilla built for the Empress Elisabeth in the Lainzer Tiergarten on the outskirts of the city, with frescoes by Makart himself.

Towards the end of the nineteenth century there was a negative reaction to this bombastic style from a younger generation of artists and architects. At the same time that Gustav Klimt was casting off his role as the establishment's chosen successor to Hans Makart and forming a breakaway exhibiting society, architects such as Otto Wagner were beginning to design buildings in a radically simplified style which repudiated the historicism of the previous era in favour of what was recognizably modern. The most outstanding examples of this specifically Viennese version of European Art Nouveau, which came to be known as Jugendstil, can be seen in Wagner's two apartment buildings on the Linke Wienzeile, one of which is clad in majolica tiles (11) and in the station pavilions and viaducts he created for line 4 of the metro, or U-Bahn. His Post Office Savings Bank, conceived in a more spare and modern idiom, is equally remarkable for its airy interior. Wagner's pupils Josef Hoffmann and Josef Maria Olbrich further disseminated and developed the style in their work for

10. H. MAKART, *THE SENSES: SMELL*, 1879
(ÖSTERREICHISCHE GALERIE)

11. O. WAGNER, THE MAJOLIKA HOUSE

12. J. M. OLBRICH, SECESSION BUILDING ›

13. A. Loos, Loos House,
Michaelerplatz

14. F. Hundertwasser, *Birth of a Car*, 1987
(Kunsthaus Wien)

private patrons of the Secessionist movement and in the Secessionist building itself (12). In 1903 Hoffmann was one of the founders of the Wiener Werkstätte, a craft workshop which influenced an entire generation of Austrian designers with its beautiful products designed to complement the new houses.

Adolf Loos, Wagner's younger colleague, was the most vehement opponent of what he saw as superfluous ornament in architecture, and his own buildings were spare and streamlined. They began with the Café Museum (nicknamed 'Café Nihilism') opposite the Secession building, which had none of the Jugendstil flourishes of most Viennese cafés, and progressed forward with the tiny American Bar in the Kärntner Durchgang, which still serves cocktails in its elegant mirrored interior. But his most notorious project was the department store and office block he designed on the Michaelerplatz, opposite the Hofburg (13). Its facade was entirely unadorned apart from the marble cladding of its first two storeys, and Emperor Franz Josef was said to keep the curtains of his apartment permanently drawn to block out the view of this 'house without eyebrows'. (What he meant by this was that it lacked the heavy curlicues or pediments that he was used to seeing over windows.) The severe modernist idiom first developed by Loos during the twenties and thirties was used for the massive municipal housing projects that the city undertook to house its workers during its 'Red Vienna' period of socialist government. Most of these blocks are unlikely to attract much attention, as they tend to be rather faceless suburban developments, but the 1300-apartment salmon and terracotta Karl Marx Hof, which stretches for half a mile long the Heiligenstädterstrasse, has become a tourist attraction in its own right.

Vienna is still at the forefront of modern movements in architecture, and there are some very exciting contemporary buildings by architects such as Hans Hollein, whose gleaming new Haas Haus faces the Stephansdom. But perhaps the most quirky of all, and certainly the most Viennese, are the Hundertwasser Haus (page 61) and the Kunsthaus Wien (page 66) by the visionary artist and designer Friedensreich Hundertwasser. His colourful buildings seem like a three-dimensional version of his patchwork-like paintings (14) and both encapsulate a love of surface decoration that remains close to Viennese hearts despite periodic purges by the purists.

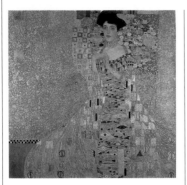

15. G. KLIMT, *ADÈLE BLOCH-BAUER I*, 1907
(ÖSTERREICHISCHE GALERIE)

The inscription on the portal of the Secession building reads 'To the Age, Its Art': a neat encapsulation of the Secessionists' desire to bring Viennese culture into the twentieth century. Viennese artistic life in the final years of the last century was dominated by a coterie of conservative older painters centred around the Kunstlerhaus, or Artist's Society. Yet a new avant garde was emerging among a younger generation of artists who congregated in a few select coffee houses to discuss alternatives to the staid naturalism that prevailed in the exhibiting halls, as well as ways of integrating the fine and applied arts. Matters reached a head in 1896, when an arch-reactionary, who had opposed the showing of the Viennese Impressionists, was re-elected as president of the Kunstlerhaus. The following year the rebels set up their own exhibiting society, and the Secession was born.

The painter Gustav Klimt (15) was elected president of the new group, which also included the architects Otto Wagner and Joseph Maria Olbrich. As though to underline their crusading zeal, the artists and designers named their journal Ver Sacrum, after a Roman ritual of consecration performed at times of danger, in which the elders pledged their children to a divine mission to save society. The first exhibition was a tremendous artistic and financial success, and the group was soon able to contemplate the creation of its own permanent exhibition space. By the time of the second exhibition in 1898 the new building, designed by Josef Maria Olbrich, had been completed. Unlike the city's other exhibition halls, modelled on Renaisssance palaces, this edifice had the quiet purity of a Greek temple, although the gold filigree dome earned it the nickname of 'the golden cabbage' from stallholders on the nearby vegetable market.

There was no absolute directive issued on style, but as a whole the group tended to favour a version of Jugendstil in which the curling tendrils and whiplash lines of Art Nouveau were subjected to a more rigorous, geometric framework. Klimt's work was always highly decorative, but that of his younger followers Egon Schiele (16) and Oskar Kokoschka, while still stressing abstract pattern and line, was more raw and expressionistic.

16. E. SCHIELE, *THE FAMILY*, 1918
(ÖSTERREICHISCHE GALERIE)

ART
IN
FOCUS

Museums

Paintings

Applied Arts

Architecture

(Gallery of the Academy of Fine Arts)

Address
Schillerplatz 3
A-1010 Wien
© 58816 0

Map reference
①

How to get there
U-Bahn: U1, U2 or U4 to
Karlsplatz.
Tram: 1, 2, D, J.

Opening times
Tue, Thur and Fri 10–2; Wed
10–1 and 3–6; Sat, Sun and
holidays 9–1.

Entrance fee
OS30 adults, OS15 for
senior citizens and
students. Free entry for
children under 10.

Tours
Guided tours every Sun at
10.30.

The Academy of Fine Arts occupies a handsome building in the Italianate style designed in 1872–76 by Theophil Hansen (who was also responsible for the Parlament building). Many of Austria's foremost artists trained here, including Ferdinand Georg Waldmüller and Egon Schiele. Adolf Hitler, whose artistic talent was more open to doubt, had his application to study at the Academy rejected.

On the second floor is an excellent gallery. Originally set up to provide a teaching resource for the students, a function it still performs, the gallery opened its doors to the public in the last century, following a gift of paintings made in 1822 by a former president of the Academy, Count Anton Lamberg-Sprinzenstein. Individual benefactors and legacies rather than extensive state patronage were responsible for supplementing the collection after that time, and perhaps because of this the gallery retains the intimate character of a private collection. The chronological span is from the Byzantine era to the twentieth century, with several works by past students and professors lining the end corridor. Although there is a good collection of Italian works, the gallery's real strengths lie in its holdings of Flemish and Dutch paintings of the sixteenth and seventeenth centuries. Vienna's most important painting by Bosch, a triptych of *The Last Judgement*, dominates the early Netherlandish and German room to the right of the gallery entrance, but there are other treasures to be found here too, including works by Cranach the Elder, Baldung Grien and Dieric Bouts. The long gallery contains an early Rembrandt portrait, De Hooch's *Family Group in a Courtyard* and exquisite self-portraits by Van Dyck and Barent Fabritius, hanging near studies for frescoes by Rubens. The eighteenth century is represented with works by Guardi, Tiepolo and the Austrian Baroque painters, while pictures by Biedermeier artists can be viewed in the nineteenth-century rooms.

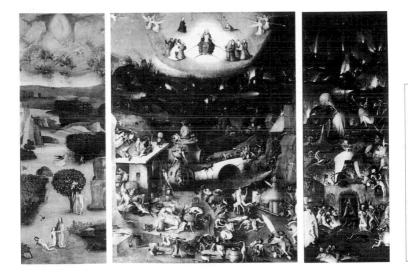

This triptych by Bosch (*c.* 1450–1516) may have been commissioned by the Habsburg ruler Philip the Fair. The fact that St. Bavo of Ghent and St. Iago of Compostela were chosen to decorate the outer wings supports this theory, since they were patron saints of the Habsburg dominions of Netherlands and Spain. Paradise appears in the left wing, the Last Judgement in the centre and Hell on the right, but in practice Hell and the Last Judgement look virtually indistinguishable. Taken as a whole, the triptych presents an overwhelmingly pessimistic view of mankind's destiny, with only the faintest hint of possible salvation.

In the Paradise panel a number of incidents take place which are separated in time but brought together in one composition. In the foreground Eve is created from Adam's rib; in the middle distance the couple pluck the apple from the Tree of Knowledge; and in the background they are banished from the Garden of Eden while the rebel angels tumble out of the sky above. Cumulatively, the episodes indicate the presence of evil in Creation from the very beginning. In the central panel Christ sits in judgement as angels blow the trumpets of the apocalypse and unspeakable torments are inflicted on those below. Some souls are roasted on a spit by demonic creatures and others pass through an infernal mincing machine or are sliced through by giant knives. The fantastic composite monsters that Bosch invented were probably assembled from a number of existing sources, including the grotesque marginalia in medieval illuminated manuscripts or even the gargoyles that adorned the church of St. John in Bosch's native town of 's Hertogenbosch.

Madonna and Child with Two Angels

c. 1480

Studio of Sandro Botticelli

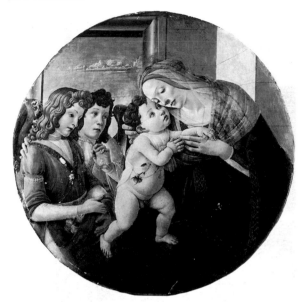

The Florentine painter Botticelli (1445–1510) was one of the most popular and sought-after Renaissance artists, and at the height of his career he ran a thriving workshop. Around the time this was painted he employed three assistants to help him, and although one contemporary described the studio as 'an academy for idlers with nothing better to do', they seem to have been kept fully occupied producing religious works, secular pictures, banners, wedding chests and portraits. The artist appears to have encouraged a genial jokey atmosphere. In his book *Lives of the Artists*, Vasari relates an episode in which Botticelli, who was attempting to sell a copy of a Madonna and Child done by one of his assistants, made some red paper hats of the type worn by Florentine councillors and stuck them on the angels' heads with wax to tease the young man who had painted the picture. Botticelli's compositions of Madonna and Child were especially popular and were obviously turned out in fairly large numbers. Yet although this picture is attributed to his studio, it seems scarcely inferior to other works which have been definitely ascribed to the master. The graceful faces framed by flowing hair and the way that the figure composition is deftly fitted into the round format are hallmarks of his style. One of the angels and the Christ child carry roses, a flower particularly associated with the Virgin, who was often described as 'a rose without a thorn'. This implied that she was a sinless being, since according to an early legend the rose did not acquire its thorns until the Fall of Man.

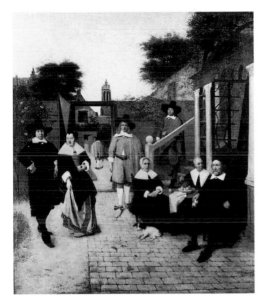

The Dutch painter Pieter de Hooch (1629–84) achieved popularity with a relatively small number of paintings produced in Delft, where he spent about a decade in the middle years of the seventeenth century. A sense of tranquillity and order pervades his best work, and this group portrait is no exception. A well-to-do burgher family pose in their garden in Delft on an overcast day. They appear to be proud of themselves and of their home, with its classically pedimented arbour. Despite the sartorial sobriety that was general at the time, small touches reveal a discreet love of finery: the lady, for example, lifts her dress to display a red underskirt, while the man in the centre wears blue breeches and extravagantly bowed shoes. A great deal of thought has gone into the placing of the figures, and some over-painting – most obvious around the man on the steps and the man at the extreme left – indicates clearly that they were moved around before a sat-isfactory arrangement was achieved. As in many of De Hooch's pictures, there is much deliberate play on perspective, and the eye is drawn into the distance by a series of receding diagonals and through carefully orchestrated compartments. A door from the main garden leads into another section of walled garden and on through a further open door, the figure of the man in the second garden giving a sense of scale and recession.

Self-portrait

c. 1613

Sir Anthony van Dyck

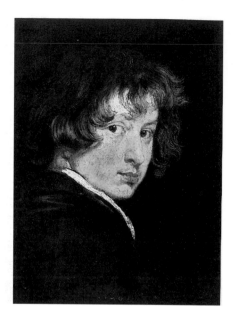

Van Dyck (1599–1641) was an extraordinarily precocious artist, and this self-portrait, painted when he was only about fourteen, is one of the unexpected jewels of the Academy's collection. Its degree of accomplishment is more readily understandable if one remembers that he began his artistic education early. By the age of ten he was already apprenticed to a successful figure painter, Hendrick van Balen, and by 1615 he had set up his own studio in Antwerp with two assistants. At that time art in the city was dominated by Rubens, with whom Van Dyck was to work as a collaborator, and this portrait has something of Rubens's free and dazzling brushwork. It may even have been Rubens who suggested to Van Dyck that he specialize in portraiture, since that was a field in which he himself was less interested. The picture shows how proud the artist was of his good looks – he was to paint several further flattering images of himself over the years. He developed into a man with a rather lordly manner who enjoyed the privileges that fame as a court portraitist in London and Antwerp brought him – superb clothing, a retinue of servants and excellent lodgings. He was also apparently attractive to women and his name was romantically linked with some of his female sitters, although he married an English cellist. However, the demands of his successful career exacted a heavy toll, and Van Dyck died prematurely at the age of forty-two.

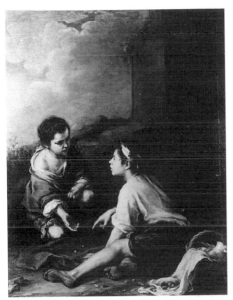

AKADEMIE DER BILDENDEN KÜNSTE

The Spanish artist Murillo (1618–82) spent his life in his native Seville, where he achieved great success as a painter both of religious subjects and of secular pictures devoted solely to scenes of children. He was one of the first painters to use vagrant and begging children as a subject for art, and his canvases were highly sought after by foreign consuls and merchants from northern Europe living in Seville, who eventually took them back to their own countries. This is why so many of them have ended up in collections outside Spain, where they became, in turn, an inspiration for eighteenth-century artists. The English painters Gainsborough and Reynolds, for example, both went through a phase of painting slightly sentimental 'fancy pictures' of ragged urchins.

Murillo began to paint young paupers quite early in his career, at a time when the genre was without precedent in Spanish art. His first depictions of these waifs were pervaded by a slightly gloomy pessimism, whereas later works such as this concentrate on their subjects' buoyancy and cheerfulness despite their evident poverty. They tend to be shown in the open air and may be eating melon, grapes or a piece of pie, about to play pelota or, as here, enjoying a game of dice. In this picture, realism – evident in the dirty feet of the foreground boy and the carefully observed still life of a pitcher in a basket – is mixed with a distinctly decorative, feathery brushstroke which is more typical of Rococo art.

Address

Augustinerstrasse 1

A-1010 Wien

✆ 53483

Map reference

②

How to get there

U-Bahn: U1, U2 or U3 to
Karlsplatz.

Tram: 1, 2, D, J.

Opening times

Mon to Thur 10–4; Fri 10–1;
Closed weekends.

Entrance fee

ÖS10.

The world's most extensive collection of graphic arts, consisting of around 50,000 drawings and watercolours and over a million printed works, is housed in a former palace at the foot of the Hofburg complex. The Albertina was named after Prince Albert of Saxony-Teschen (1738–1822), husband of Archduchess Maria Christine who was daughter of Empress Maria Theresia, since his collection formed the basis of the museum. It was he who also acquired the former Taroucca Palace at the beginning of the nineteenth century and who asked the architect Louis de Montoyer to remodel and extend it to incorporate part of the neighbouring Augustinian monastery. Although the building was badly damaged during World War Two, the interiors retain an impression of their original grandeur.

Because the collection is so large, only a fraction of it can be seen at any one time, and extensive rebuilding currently in progress has limited the display area still further. High-quality facsimile reproductions of the most famous works are usually on exhibition, but owing to their fragile nature many of the originals are accessible only to scholars. The collection of around 145 Dürer drawings and watercolours is outstanding; it includes his well-known works *The Hare*, *Praying Hands*, *Wing of the Common Roller* and *Piece of Turf*. Fellow German artists Holbein, Cranach the Elder, Altdorfer and Baldung Grien are also represented here, as are the Flemish and Dutch artists Bruegel, Rubens, Bosch and Rembrandt. Among the Italian holdings are forty-three drawings by Raphael and works by Michelangelo, Leonardo, Mantegna, Fra Angelico, Tintoretto, Tiepolo and Canaletto. The gallery has works by seventeenth- and eighteenth-century French artists Claude, Poussin, Fragonard, Watteau and Liotard, as well as more modern examples by Matisse, Picasso and Chagall. There is also a large collection of Austrian art from the Baroque era to the present; Egon Schiele is particularly well represented.

The ancient Augustinerkirche, with its undecorated facade, lies along the outer edge of the Hofburg complex. Several royal weddings have taken place here, including those of Maria Theresia, Emperor Franz Joseph, and Napoleon and Marie-Louise. The Loreto chapel, dating from 1724, has a niche lined with silver urns containing the hearts of the Habsburgs (their disembowelled bodies repose in the burial vault in the Kapuzinerkirche and their entrails lie beneath the high altar of the Stephansdom). Originally built for the Augustinian monks in the 1330s, the church was later overlaid with Baroque decoration before being re-Gothicized at the end of the eighteenth century. The result is an impressively spare interior, relieved by Rococo carved pews and a magnificent organ by Johann Baptist Straub on which Bruckner's Mass in F minor was first performed. The star feature is the Italian sculptor Canova's marble monument to Maria Theresia's daughter Maria Christine of Saxony Teschen, which takes the form of weeping figures entering a pyramidal tomb and dates from 1805.

Address
Augustinerstrasse 3
A-1010 Wien
© 5337099

Map reference
③

How to get there
U-BAHN: U1 or U3 to
Stephansplatz or U3 to
Herrengasse.
TRAM: 1, 2 or J.

Opening times
Mon to Sat 7–6; Sun 1–6.

★ ÖSTERREICHISCHES BAROCKMUSEUM
(AUSTRIAN BAROQUE MUSEUM)

LOWER BELVEDERE: BAROCKMUSEUM

Address
Unteres Belvedere
Rennweg 6a
A-1037 Wien
✆ 7841580

Map reference
④

How to get there
U-BAHN: U1, U2 or U4 to
Karlsplatz, or U1 to
Taubstummengasse.
TRAM: D, 71.

Opening times
Tue to Sun 10–5.

Entrance fee
OS60 (combined ticket with
Museum mitteralterlicher
österreichischer Kunst and
Österreichische Galerie des
19 und 20 Jahrhunderts).

Tours
Wed 2.30 in English.

Occupying the gracious rooms of the Lower Belvedere Palace, the Baroque Museum, housed here since 1923, presents the best of Austrian painting and sculpture produced in the century or so between the end of the Turkish siege in 1683 and the beginning of the Napoleonic era. Once the Turkish menace had been banished forever, a period of peace and prosperity allowed the arts to flourish as never before, and Vienna became a magnet for artistic talent from all over the Austro-Hungarian Empire and beyond. It was during this golden age that the city's most famous palaces and churches were built, and the work of several of the artists and sculptors who decorated these magnificent buildings is on show here.

Johann Michael Rottmayr, whose masterpiece is the cupola fresco in the Karlskirche (page 62), is represented by a painting of *Tarquin and Lucretia*, while *Susannah and the Elders* is the work of Martino Altomonte, who painted several of Vienna's altarpieces. He was also responsible for the extravagant ceiling fresco showing *The Triumph of Prince Eugene* in the Marble Hall, as well as other ceiling frescoes in Rooms Eight and Ten. In addition there are oil studies by Daniel Gran, the creator of the extraordinary ceiling of the Prunksaal in the National Library (page 60), by Paul Troger and by Martin 'Kremser' Schmidt. Perhaps the most outstanding sculptures on show are Georg Raphael Donner's lead figures for the Neuer Markt Fountain, while Messerschmidt's series of grotesque heads add a comic note to a rather serious collection.

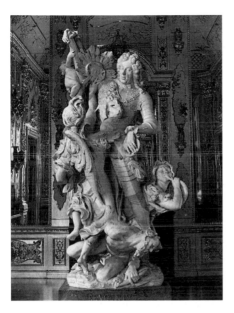

The Building

The twin palaces at the Belvedere were commissioned by Prince Eugene of Savoy, the military hero who finally banished the Turks from the gates of Vienna in 1683 and later expelled them from Hungary. He bought the site on the southern edge of the city in 1693, and then some time later asked Johann Lukas von Hildebrandt to draw up the designs. Johann Bernard Fischer von Erlach had already started work on Schloss Schönbrunn (page 118), and, like his rival, Hildebrandt had it in mind to outdo Versailles in the magnificence of his scheme. The two palaces are linked by a formal garden in the French style, with terraces, cascades and statuary laid out according to a complicated mythological programme.

The first of the two buildings to be completed, the Lower Belvedere, was where the Prince actually lived each summer, whereas the Upper Belvedere was reserved for entertaining. The splendid interior provides a fitting setting for the Barockmuseum. At the centre of the building the Marble Hall extends over two storeys and offers a riot of coloured marble pillars and reliefs and painted architectural perspectives, surmounted by a painted ceiling glorifying the illustrious military leader. The Grotesque Hall is decorated with grotesque frescoes by Jonas Drentwett; this leads into the stucco-encrusted Marble Gallery, where audiences were once held. But perhaps the most spectacular room of all is the small Gold Cabinet at the end of the series of apartments, in which Permoser's statue of Prince Eugene (commissioned by the sitter himself) sits in the middle of a mirrored room whose gilded walls are lined with Oriental vases.

The Providentia Fountain Figures

1737–39

Georg Raphael Donner

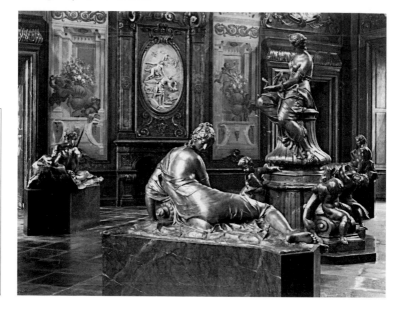

It was the city fathers who commissioned Georg Raphael Donner (1693–1741) to create the Providentia Fountain in the Neuer Markt. The result was an extraordinary masterpiece, designed to be viewed from all angles. In the centre of the fountain is an enthroned statue of Providence who faces two ways; the city government intended that she should represent their collective wisdom. Four putti disport themselves around the base of the centrepiece, while four allegorical figures representing the Austrian tributaries of the Danube adorn the fountain's perimeter. The Enns is shown as an old man and the Traun as a muscular youth, while the Ybbs and March are personified as women. The Traun displays his buttocks prominently to the onlooker; in its original position the statue was pointing at the window of a former patron whom Donner wished to insult. The original figures were removed in 1770 at the request of Empress Maria Theresia, who objected to their nudity, and the sculptor Johann Martin Fischer kept them safely until they were replaced in 1801 during the reign of Franz II. However, they were removed again in 1873 because they were badly in need of restoration and they are now safe from the ravages of the elements in the Barockmuseum. Those in the Neuer Markt are bronze copies of the originals.

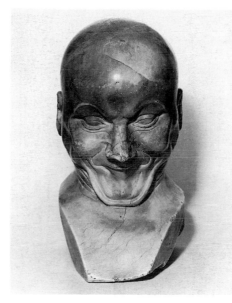

The Grotesque Hall houses a series of grotesque heads by Franz Xaver Messerschmidt (1736–86), the most important Baroque sculptor in Austria during the second half of the eighteenth century. Having studied in Vienna, Messerschmidt travelled to Rome and London before returning to the Austrian capital to take up a teaching post at the Academy. The sculpted portraits of Maria Theresia and her husband Franz Stephan of Lorraine usually housed in the Barockmuseum's Marble Gallery testify to his accomplishment and success as a conventional court artist. However, madness began to torment him, and in 1777 he went to live a hermit's existence in Pressburg (present-day Bratislava), where he devoted himself to creating a unique series of sixty-nine character heads, mostly in lead or soft stone, materials which lent themselves to fluid, expressive modelling. The heads are remarkable for their unadorned nakedness of form, which gives them a curiously modern feel. Intended primarily as studies of temperament, types of character and mood, they were based upon the physiognomic researches of Lavater but reflect to some extent Messerschmidt's own disturbed mental condition. Yet they also echo a wider Baroque interest in individuality and expression that was ultimately to lead to the development of the caricature. This went against an opposing trend towards the ideal and universal seen in the work of a slightly younger generation of Classical sculptors such as Franz Anton Zauner, who created the bronze equestrian statue of Emperor Joseph II in the square outside the National Library.

Museum mittelalterlicher österreichischer Kunst

(Museum of Austrian Art from the Middle Ages)

Address
Unteres Belvedere
Rennweg 6
A-1037 Wien
✆ 7841580

Map reference
⑥

How to get there
U-Bahn: U1, U2 or U4 to
Karlsplatz.
Tram: D, 71.

Opening times
Tue to Sun 10–5.

Entrance fee
OS60 (combined with
Österreichisches
Barockmuseum and
Österreichische Galerie des
19 und 20 Jahrhunderts).

The Orangery to one side of the impressive Lower Belvedere (page 27) is the home of the museum of medieval Austrian art. The building itself dates from 1720, but it was largely rebuilt after World War Two and the gallery opened in its present form in 1953. It may not be as flamboyant as its neighbour, but it provides an airy and spacious environment for the large altarpieces and sculptures that make up the bulk of the display, and as it is a fairly small gallery it may easily be seen at a relaxed pace in an hour or so. The chronological span is from the end of the twelfth century to the sixteenth, but there is a strong emphasis on the fifteenth century, with works in the International Gothic style and paintings by artists of the Danube School. The space is divided into five sections which flow into each other. In the first part you come to is a series of stone figures by the Master of Grosslobming; in the second a number of fifteenth-century Crucifixion scenes by Austrian masters including Conrad Laib. Perhaps the most fascinating series occur in the third and fourth sections, where you will find five pictures by Michael Pacher and seven by Rueland Frueauf the Elder, as well as two panels by the Master of the Schottenaltar. In the final section the star exhibit is Urban Görtshacher's *Ecce Homo*. Further examples of medieval Austrian art can be seen in the gallery at Klosterneuberg (page 64), in the treasuries of the Hofburg (page 58) and the Teutonic Order (page 117), and in the Dom und Diözesan Museum (page 48).

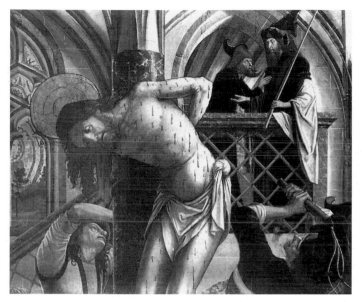

Michael Pacher (*c*. 1440–98) was a Tyrolean artist who worked chiefly in his native region of Carinthia and the Salzkammergut, and who seems to have run an influential workshop. His most celebrated work was the high altar at the Church of St. Wolfgang on the Abersee. Five of his pictures are on display in the museum. This particular panel was part of the high altar of the Franciscan church in Salzburg and it depicts the scourging of Christ prior to the Crucifixion. Jesus is tied to a pillar in a Gothic building, while soldiers administer his punishment. Two figures in the background, one of whom must be Pontius Pilate, are spectators at the torture. One of the soldiers appears to be entreating the other, and the expression of physical effort in their faces is quite remarkable. *The Flagellation* exhibits an intriguing mixture of Gothic and Renaissance ideals. It shows clearly that although Pacher, like many artists of his generation, was highly influenced by the colour and detail of Netherlandish artists such as Rogier van der Weyden, he was also receptive to Italian Renaissance ideas about perspective and foreshortening. The proximity of the Tyrol to northern Italy brought artists like Pacher into contact with art from that area, and this composition, with its bold manipulation of space, monumentality and low viewpoint, surely owes something to the example of the Italian artist Mantegna.

The Road to Calvary

1490–94

Rueland Frueauf the Elder

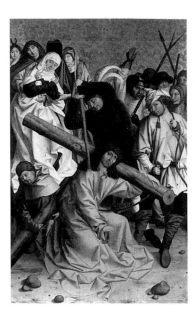

Like Michael Pacher, Rueland Frueauf the Elder (*c.* 1440–1507) undertook important commissions in Salzburg. Seven panels from an altarpiece he painted for the Benedictine Abbey of St. Peter there are on display in the museum; the eighth is currently in restoration. The large panels, which must have constituted a massive winged altar when assembled, show *The Annunciation*, *The Adoration of the Three Kings*, *The Assumption*, *Christ on the Mount of Olives*, *The Flagellation*, *The Road to Calvary* and *Christ on the Cross*, although how these were arranged in the original altarpiece is not known. It is quite possible that the interior was a sculpted panel, but if so it has been lost. The pictures are characterized by energetic movement, monumental figures and tightness of composition. In *The Road to Calvary* (illustrated above) Christ is beaten with a stick as he falls to his knees under the weight of the cross; St. John the Baptist supports the swooning Virgin while Mary Magdalene, sporting an extraordinary headdress, appears in the background and soldiers with lances lead the way forward. The fact that the drama is set against a gold background probably indicates that this panel was one of the inner scenes revealed on Sundays and feast days. Frueauf's son, who bore the same name, painted a delightful series of pictures with attractive landscape backgrounds for the St. Leopold altar at Klosterneuburg, where they can still be seen in the gallery (page 64).

Ecce Homo

1508

Urban Görtschacher

'Ecce Homo' were the words uttered by Pontius Pilate when he showed Jesus to the mob after his flagellation in the judgement hall. Christ wears the emblems of kingship with which he has been ironically invested – the crown of thorns and the red cloak – and his body bears the marks of his scourging. The crowd below calls for his crucifixion with crossed fingers and weapons. Although the subject is a grim one, Görtschacher (active early sixteenth century) invests it with some lovely details that serve to divert attention from the essential brutality. The Italianate architecture adds a note of elegance to the proceedings, as do the sumptuous clothes and the exuberantly curling scrolls bearing the mob's words. Yet there is something unmistakably Germanic about the faces in the crowd, which at times verge on caricature.

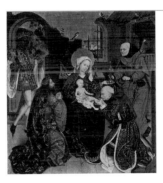

The Adoration of the Magi

c. 1470/80

The Master of the Wiener Schottenaltar

In the fifteenth-century Vienna was a centre of artistic activity, and the anonymous Master of the Wiener Schottenaltar (active c. 1470/80) was the foremost artist working there. This is one of two panels in the museum which originally belonged to the main altarpiece in the Viennese Benedictine Abbey, or Schottenstift. The complete altarpiece showing the *Life of the Virgin* and *The Passion* (with copies of the museum's two panels) can occasionally be viewed at the Schottenstift when the gallery is open. The colour and surface detail in the picture show the influence of early Dutch painters such as Dieric Bouts and Geertgen tot Sint Jans (see page 77). The semi-naturalistic way in which the gold background (presumably requested by the patron) has been used to suggest sunset is a particularly pleasing innovation.

★ ÖSTERREICHISCHE GALERIE DES 19 UND 20 JAHRHUNDERTS

(AUSTRIAN GALLERY OF THE NINETEENTH AND TWENTIETH CENTURIES)

Address
Oberes Belvedere
Prinz-Eugen-Strasse 27
A-1037 Wien
✆ 7841580

Map reference
⑦

How to get there
U-BAHN: U1 to
Taubstummengasse.
TRAM: D, 71.

Opening times
Tue to Sun 10–5.

Entrance fee
OS60 (combined ticket with
Osterreichisches
Barockmuseum and
Museum mittelalterlicher
österreichischer Kunst).

Tours
In English every Wed at
2.30.

This is the museum to head for if you want to see the highlights of turn-of-the-century Viennese painting. The rooms full of works by Klimt, Schiele and Kokoschka have long been one of Vienna's chief tourist attractions, and they are almost guaranteed to remain open even when other parts of the building are temporarily closed, as they have been in recent years, for restoration. However, it is actually more interesting to view the entire collection so that these pictures can be seen in their historical context, as part of the development of Austrian art over the hundred or so years from the early nineteenth century. The Österreichische Galerie takes up the story that ended with the exhibits in the Barockmuseum, beginning with the work of the Neoclassicists. These lead on to the essentially private cosy canvases of Biedermeier painters such as Waldmüller and Amerling, who were working in the first half of the nineteenth century. The rather overblown style of the Ringstrasse era which followed reached its epitome in canvases by Hans Makart, who espoused the type of historicism also seen in the Ringstrasse architecture. It was precisely this kind of historical eclecticism that the artists of the Viennese Secession were reacting against.

Also on show is a selection of paintings from the Neue Galerie, which was housed until quite recently in the Stallburg, or Imperial Stables, and is now awaiting a new home. This is an excellent collection of non-Austrian paintings from the nineteenth and early twentieth centuries, with particular emphasis on French and German works. Corot, Millet, Courbet, Manet, Monet and Renoir are shown alongside Friedrich, Van Gogh, Trubner, Leibl, Liebermann, Segantini and Munch.

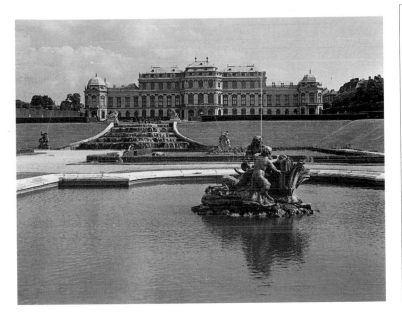

The guests who attended Prince Eugene's masked balls and firework displays were accommodated in grand style in the Upper Belvedere, which looks down on the formal garden and the Lower Belvedere from its high vantage point and has its own separate entrance on the Landstrasser Gürtel. Passing through the lovely wrought-iron south gates the visitor can see the elegant facade of the palace mirrored in a large pool of water where small gondolas once floated. The fantasy effect created by the Rococo decoration is heightened by the long roofs of the main building, which bear more than a passing resemblance to the shape of ceremonial Oriental tents, and by the mosque-like domes on the octagonal side pavilions. The entrance to the building from the garden side is through the Sala Terrena, or Garden Room, whose stuccoed vault is supported by massive Herculean figures. The staircase rising out of the entrance hall carries military trophies, emblems of war and scenes from the life of Alexander the Great. On the first floor, a two-storey Marble Hall echoes a similar one in the Lower Belvedere, and a surprisingly highly coloured ceiling by Carlo Carlone presents an *Allegory of Fame*. It was here that the Austrian State Treaty was signed in 1955, giving the country her independence again after the Allied occupation. There is a chapel with an altarpiece by Solimena and cupola decoration by Carlone in the south-east pavilion, while the north-west one contains a Gold Cabinet.

Ravine in the Elbsandstein

1823

Caspar David Friedrich

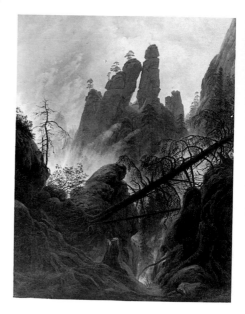

The German artist Caspar David Friedrich (1774–1840) was one of the greatest Romantic painters. He imbued the landscape with a symbolic, spiritual and emotional meaning, drawing his inspiration entirely from the countryside around Dresden, where he spent most of his life, from the Harz mountains and the Baltic coast. Friedrich's art is resolutely northern, Gothic and Christian in atmosphere – the sunshine and classicism of Mediterranean lands never appealed to him. This painting shows a ravine near Dresden, the group of rocks in the background being recognizable as the Neurathen Pass in the Elbsandsteingebirge, although they are depicted as higher than they are in reality; Friedrich often took extreme liberties with topography in the interest of compositional drama. Nothing is ever accidental or without deliberate significance in his work, and he was not reliant on human presence to convey the burden of meaning, preferring to use the landscape itself as the vehicle of his inner religious vision. He employed associations which were already well-known rather than personal and obscure, so that evergreen fir trees stood for eternity, ruins for transience, the sun's rays for the light of Christ and so on. While his pictures often seem gloomy or despairing, they were intended to provoke contemplation and point to the eventual attainment of peace and oneness with God. According to a fairly conventional reading, the ravine with its fallen fir tree may be seen as an allegory on death and eternity, the darkened foreground leading to sublimity beyond.

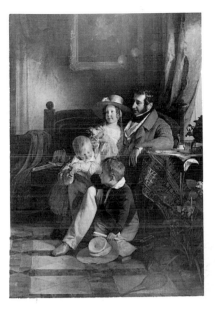

A native of Vienna, Amerling (1803–87) was the city's most fashionable portraitist in the mid nineteenth century. He was just thirty-three when he painted this group portrait. Four years earlier he had achieved his first success with a specially commissioned portrait of Kaiser Franz seated on his throne wearing Imperial robes. This informal picture, however, is a far cry from the official state portrait. It shows the wealthy textile manufacturer and exporter Rudolf von Arthaber, who was also a keen art collector and owned nine canvases by the Amerling, sitting at home with his three children. He gazes at a portrait of his dead wife which the youngest child is holding up against his knee, so the mother's presence is implied if not real. Despite the melancholy potential of such a subject, the children give the picture a charming and lighthearted atmosphere that is reminiscent of genre painting. The everyday objects of the household are beautifully observed, including the abandoned tennis racket on the floor and the open picture-book on the sofa, which the children have obviously been playing with only a moment before. Details such as the pot plants, the cloth on the table, the samovar and the cup are meticulously delineated, displaying a typically Biedermeier love of home comforts and cosiness.

The Plain at Auvers

1890

Vincent van Gogh

A radiant picture of a plain in high summer, this landscape was painted barely a month before Van Gogh (1853–90) took his own life by shooting himself in the chest. According to reports in the local press he did so in a field. The artist had left his native Holland for good in 1886 and gone to live in the south of France, where he began to produce his highly coloured and expressive landscapes and portraits. From the start he was dogged by periods of depression and insanity. He had hoped to found an artists' colony in Arles, but his plans ended abruptly when his fellow painter Gauguin departed after a quarrel and Van Gogh cut off the lobe of his right ear. On 16 May he left Arles and made his way via Paris to Auvers, a pretty town to the north-west of Paris, where Paul-Ferdinand Gachet, a kind and eccentric doctor and art lover, was to keep an eye on his mental condition. Auvers appealed to Van Gogh, and during the last two months of his life he engaged in a frantic bout of activity, producing about seventy oils, thirty watercolours and drawings and one etching. Around thirty of these pictures were wide sweeping landscapes or, as the artist referred to them, 'fields seen from a height'. Some of them showed fields of wheat under troubled skies, while others, such as this, have a more optimistic mood, displaying his delight in the delicate play of colour and pattern formed by the different crops. This is a remarkable testimony to Van Gogh's grasp of colour and composition, which never wavered even at the height of his mental turmoil.

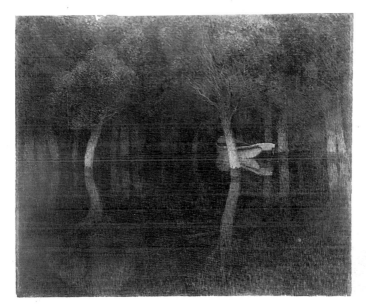

Carl Moll (1861–1945) was one of a group of artists who, following the lead of Klimt, resigned from the Kunstlerhaus in 1897 to form the Secession. He had trained under the Viennese landscape artist Emil Jakob Schindler – later marrying his widow, Alma Mahler's mother – and by the time this was painted he had progressed from his master's naturalistic manner of painting towards a more sombre Symbolist mode. In its subdued tonality, melancholy mood and essential mystery, this painting comes close to the work of other European Symbolists such as Fernand Khnopff or Arnold Böcklin. The motif of an empty boat lost among trees against a watery landscape, in which it is difficult to tell where river and reflection begin and end, is at once suggestive of themes such as death, silence, ending or illusion; but the picture eludes precise interpretation. It is poetic and atmospheric rather than anecdotal.

In the early years of this century Moll abandoned this way of working and lightened his palette, adopting a more colourful, almost Impressionist style. He himself was a patron of fellow avant-garde Viennese artists and craftsmen, and his own house on the Hohe Warte, built by Josef Maria Olbrich and furnished by the Wiener Werkstätte, often features in his paintings of quiet interiors.

The Wicked Mothers

1894

Giovanni Segantini

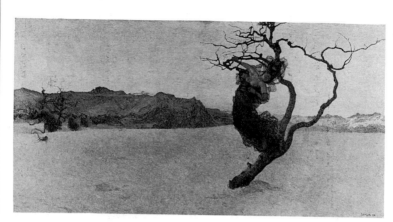

The Italian artist Segantini (1858–99) married the subject matter and imagery of Symbolist art with the divisionist brushstroke initially developed by the Impressionists, who were generally more concerned with purely visual painting. In this picture he used long broken brushstrokes within a relatively limited colour range to suggest the effect of sunlight and shadow on snow. Segantini found spiritual inspiration in the mountains and high horizons of the Alps, where he retired to live in 1881. He employed the forms of nature as visual equivalents of ideas about good, evil and human morality, and like other Symbolist artists, he used the seasons to echo the moods of humanity. Here the gnarled and twisted tree trunks set in a barren winter landscape suggest sin and suffering. A whole stream of mothers pours out of the background mountain range, progressing towards a woman who is entangled in a tree like an insect without wings. The head of a child growing out of the branches attempts to suckle at her breast. The precise nature of the mothers' wickedness referred to in the title is not disclosed, but there is some hint at sexual ecstasy in the facial expression of the woman and in the fact that she wears little more than a film of almost transparent gauze. In this respect the painting makes an interesting parallel with the works by Klimt and Schiele displayed nearby, which also link sexuality, pain and death.

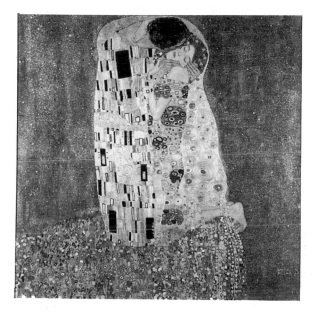

Perhaps the best-known work by Klimt (1862–1918), this picture has become so familiar through postcards, posters and other merchandise that it is the ultimate symbol of fin-de-siècle Vienna. A pair of lovers embrace against a golden background reminiscent of Byzantine or Russian icons. They appear to be kneeling in a highly stylized meadow studded with flowers, while golden tendrils trail over the woman's legs. The scene looks like an Arcadian idyll, but the fact that the ground terminates abruptly at the right adds a hint of menace. Could it be that the lovers are about to slide into an abyss?

While the two bodies seem to be enclosed within a golden aureole which is almost phallic in form, they are distinguished by the different decorations on their garments. The man's robe is covered with black and white rectangles, emblematic of masculinity, while the woman's dress, which clings to her body revealing her curves, is adorned with circular motifs that echo the forms of the flowers and suggest more feminine attributes. Flowers also appear in her hair, while the man is crowned with a wreath of ivy. Embracing lovers form a frequent motif in Klimt's work – similar couples appear in the designs he made for the mosaic for the dining room of the Palais Stoclet in Brussels and in the *Beethoven Frieze* in the Secession building (page 121). In all the versions of the theme the man is the dominant partner and the woman adopts a more submissive pose.

Judith I

1901

Gustav Klimt

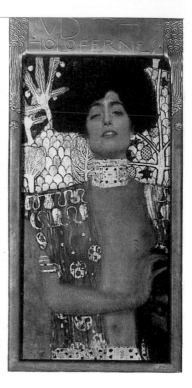

Femmes fatales are a constant feature in the work of Klimt (1862–1918), and the theme of Judith was one that he depicted on two occasions: in this picture of 1901 and in a later life-size version of the subject painted in 1909, now in the Galleria d'Arte Moderna in Venice. Adèle Bloch-Bauer, who is said to have had a long-term affair with the artist, probably modelled for both pictures. The Old Testament relates how Judith, an attractive Jewish widow, saved the city of Bethulia from siege by the Assyrians. When the inhabitants were on the point of surrender, she adorned herself and entered the enemy camp in order to meet the commander Holofernes. Captivated by her beauty, Holofernes invited her to a banquet hoping to seduce her. When they were alone after the meal, she took advantage of his drunkenness to decapitate him and returned to her city with the head in a sack. On learning the news the Assyrians fled in disarray.

Klimt's Judith wears an expression of cruel rapture that verges on sexual ecstasy as she gazes at the spectator beneath heavily lidded eyes while brandishing her grisly trophy. The jewel-encrusted choker which separates her head from her body provides a morbid reference to the fate of her victim. Many of Klimt's contemporaries could not believe that this sadistic woman represented the pious Jewish heroine, and during his lifetime the picture was thought to show Salomé – a lascivious temptress whose sensual dance before King Herod brought about the death of John the Baptist. The schematized gold fig trees and vines in the background are based on a famous Assyrian relief at the palace of Sennacherib.

1916

Gustav Klimt

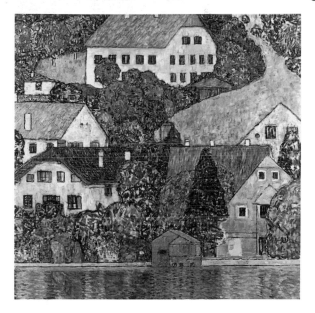

From 1906 to 1916 Klimt (1862–1918) spent three months every summer staying with his companion Emilie Flöge and her family at their holiday home on the Attersee, a lake in the Salzkammergut area. It was an idyllic interlude away from city life. He would rise early in the morning and paint before having breakfast and a swim, then spend the rest of the day either studying his books of Japanese prints, painting or rowing on the lake. The extraordinary series of landscapes he produced here are just as remarkable as his figure paintings, although perhaps less famous. Many of the pictures were started and some were finished in the open air rather than from sketches in the studio. Yet Klimt appears to have been aiming for a different effect from the Impressionists, who had first adopted this way of working. He was less interested in capturing a specific moment or a transient light effect than in creating a stable and unchanging composition in which each element was precisely placed.

This view of a lakeside village was obviously painted from a boat looking towards the shore. Its slightly claustrophobic feeling and flattened perspective are entirely typical of Klimt's landscapes. The artist chose to focus on a fairly narrow vista; there is little sense of recession and the dwellings seem to be stacked up on top of each other. It is hard to tell how steeply the hill rises behind the first row of houses, nor is there any horizon line, and so the scene is transformed into an almost abstract pattern.

The Tigerlion

1926

Oskar Kokoschka

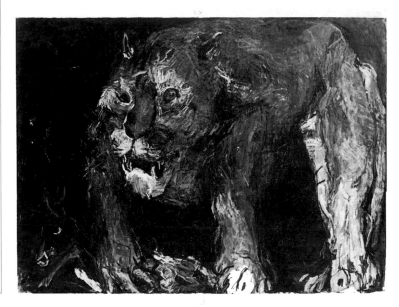

A major Expressionist painter, Oskar Kokoschka (1886–1980) came under the influence of Klimt, Schiele and the Secessionist movement while he was a student at Vienna's School of Applied Art. His art, like theirs, was subject to extreme linear distortion, but it is less rarefied, possessing a unique nervous energy. As a portraitist he was not concerned with decoration or compositional harmony like Klimt, preferring to probe beyond superficial appearances and reach towards the inner torments of a person, bringing out their worries, angst and demons. In his private life he cultivated a 'bad boy' persona, shaving his head like a criminal to underline his role as an opponent of bourgeois complacency.

In keeping with Kokoschka's tendency to home in on the untamed, this painting of a lion emphasizes the savagery of the beast, which seems to be in the process of ripping its prey apart with murderous paws while baring its fangs to the onlooker. Its tensed body is delineated with restless brush-strokes, creating an image of ruthless vigour. This impression of menace is amplified by the fact that the animal fills the entire picture frame as it looms into view. Just as the artist often placed his portrait sitters against a blank background so that nothing distracted from their essential character, so the lion is given no context: it is impossible to tell if it is in a landscape or a zoo.

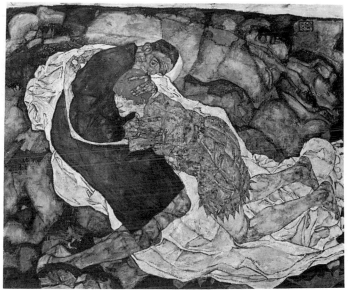

The twin themes of sexuality and death run through most of the work that Schiele (1890–1918) produced during his brief career. They were also major preoccupations amongst certain Viennese scientists and writers in the early years of this century, when Freud was first formulating his theories of psychoanalysis, Arthur Schnitzler was writing a sexual comedy of manners entitled *La Ronde* and Richard Krafft-Ebing was investigating human sexual behaviour. Schiele adds a particularly personal dimension to the subject here. One of his most disturbing images, *Death and the Maiden* shows two figures locked in a desperate embrace, a young woman and a cadaverous-looking man with sunken eyes – a personification of death itself – in a monk's habit. The suggestion of sex is implicit in the rumpled white sheet on which the couple lie. Death's features are reminiscent of Schiele's own, and the device of the spread fingers is one seen in his self-portraits (page 55). The woman's face resembles that of Wally Neuzil, his mistress and model, whom he discarded in order to marry the more respectable Edith Harms (page 46) the year that this was painted. It may be that the picture was intended as some kind of valedictory comment on the ending of the affair. The action is set against an indistinct background which appears to be rocks, with creatures resembling scorpions crawling round the crevices.

Edith Seated

1917/18

Egon Schiele

Early in 1914 Schiele (1890–1918) got to know two attractive girls, Adèle and Edith Harms, who lived in an apartment opposite his studio. Although he was still living with artist's model Wally Neuzil at the time, he pursued first Adèle and then her sister, finally marrying Edith in the following year. Her respectable, bourgeois family did not approve of the match, but to judge from her letters Edith appears to have been very much in love with her husband. Less is known about Schiele's feelings for her, but in the tender portraits he painted of her she is always invested with an appealing fragility and innocence. In this picture his wife is set against an indeterminate background. Originally she was shown wearing a brightly chequered skirt, but this was later overpainted at the request of the Director of the Österreichisches Galerie, who bought the picture the year after it was painted. As in other canvases by Schiele – for example *Death and the Maiden* (page 45) – the figure appears to be seen from above. Although she is looking to the right her torso twists to the left, and this, with the position of her arms, means that the body fits into a neat oval. This style of painting, in which forms are rounded and three-dimensional, marked a decisive step away from the anguished angularity of Schiele's earlier works, such as his *Self-portrait with Spread-out Fingers* (page 55).

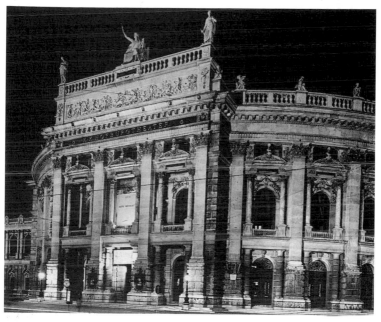

Home to one of the most prestigious stages in the German-speaking world, the Burgtheater was the last public building to be constructed along the newly laid-out Ringstrasse. Gottfried Semper and Karl von Hasenauer designed it in the Italian Renaissance style as a semicircle flanked by two long wings, each containing a grand staircase. The building opened in 1888, only to close for further modifications nine years later when it was discovered that several seats had no view of the stage and the ceiling cupola made for appalling acoustics. Bombing during World War Two destroyed the central part of the theatre, which has been totally reconstructed. However, the two staircases were left intact, which is fortunate since they are the chief artistic attraction. The staircase ceiling frescoes by Gustav and Ernst Klimt and Franz Matsch depict the development of the stage from antiquity through the Middle Ages to later centuries.

Address

Dr. Karl-Lueger-Ring 2
A-1014 Wien
© 514442955

Map reference

⑨

How to get there

U-Bahn: U2 to Rathaus or Schottentor.
Tram: 1, 2, D, T, 37, 38, 40, 41, 42, 43, 44.

Opening times

Unless attending a performance, the building must be seen on a guided tour. July and August: Mon, Wed, Fri at 1, 2, and 3. Otherwise according to theatre programme. Ring for up-to-date information.

Dom und Diözesan Museum
(Cathedral Museum)

Address
Stephansplatz 6
A-1010 Wien
© 51552560

Map reference
(10)

How to get there
U-Bahn: U1 or U3 to
Stephansplatz.

Opening times
Tue, Wed, Fri, Sat 10–4;
Thur 10–6; Sun 10–1.

Entrance fee
OS40 for adults; OS20 for
senior citizens, students
and members of orders.

Tours
By arrangement only.

In 1365 Duke Rudolph IV of Austria, who had the Stephansdom rebuilt in the Gothic style, gave his large collection of relics to the Cathedral Chapter. This treasure, together with a tempera portrait of the Duke and other works of art and objects of a devotional nature are displayed in this museum. It is housed in the former Archbishop's Palace (1630–40) next to the Stephansdom. The chronological span is from medieval times to the present day, and all branches of the fine and applied arts are represented. The showcases abound with liturgical objects, altar furnishings and monstrances for showing relics – one purporting to hold the cranium of St. Stephen. Among the other exhibits are some attractive Styrian glass flasks; a twelfth-century portative altar with enamel plaques; and several manuscripts, including an illuminated Carolingian Gospel Book from the ninth century and two lovely Missals from the fifteenth century.

One room is dominated by large late medieval panel paintings. The polyptych of Ober St. Veit showing the Crucifixion was painted in 1507 by one of Dürer's followers and is closely based on the master's sketches. There are also works by the 'Albrecht' Master (whose masterpiece is at Klosterneuburg, page 64) and Lucas Cranach the Younger. Many carved wooden figures grace the rooms, prominent among them a St. Anne grouping by Veit Stoss and an early fifteenth-century shrine Madonna. This is the place to see smaller-scale pictures by Austria's leading eighteenth-century Baroque artists who are better known as frescoists, such as Paul Troger and Franz Anton Maulbertsch. A small chapel holds nineteenth-century paintings by artists including Julius Schnorr von Carolsfeld and, slightly out of place, writing tools that once belonged to Beethoven. The Otto Mauer and Ferdinand Klosterman Collections, given to the museum in the 1980s, have added twentieth-century Austrian art to the holdings, and regular exhibitions of contemporary art are held.

The imposing colonnaded Neue Burg wing of the Hofburg, from whose terrace Hitler proclaimed the Anschluss in 1938, houses four collections: the Ephesos Museum, the Weapons Collection, the Musical Instruments Collection and the Ethnography Museum. Entrance to the Ethnography Museum is separate (see page 113), but the first three collections are entered from the central portal and one ticket gives access to all of them. While it is certainly worth a detour to see Haydn's harpsichord and pianos belonging to Brahms, Beethoven and Mahler, and to marvel at the elaborate suits of armour, by far the most interesting museum from an artistic point of view is the Ephesos Museum.

Because Austrian archaeologists were (and still are) in charge of excavations at the Turkish city of Ephesus, Vienna has the only collection of finds from the city outside that country. Digging continues to this day, but everything on show here was found between 1866 and 1907; since that date it has been illegal to export antiquities from Turkey. The objects are well displayed in light, airy halls, and a wooden model of the city of Ephesus gives some idea of the scale of the excavations. The most remarkable single item is the Parthian frieze, an enormous relief which once ran round a memorial monument (page 50). Ancient Ephesus was the centre of a cult devoted to Artemis, and fragments of a temple dedicated to the goddess are here, as are reliefs, friezes and carvings from other buildings. In addition, the museum houses a number of Roman copies of Greek statues; the heavily reconstructed bronze figure of an athlete, which is given pride of place, is particularly fine. Exhibits from Samothrace, an island in the north-east Aegean which was once a religious centre, round off the display.

Address
Neue Hofburg
Heldenplatz
A-1010 Wien
✆ 521770

Map reference
⑪

How to get there
U-Bahn: U2 to Mariahilferstrasse.
Tram: 1, 2, D, J.

Opening times
Mon, Wed to Sun 10–6.

Entrance fee
ÖS30.

The Parthian Frieze

C. AD 170

This monumental forty-metre-long marble frieze with lifesize figures stretches along two walls of the Neue Hofburg. It was originally created to decorate a pantheon in honour of Lucius Verus, who lived AD 130–69 and ruled the Roman Empire jointly with his adoptive brother Marcus Aurelius. Lucius had his headquarters initially in Antioch and subsequently in Ephesus. The reliefs depict episodes from his life, notably his victory against the Parthians, and associate his successes with Roman gods and goddesses. Drawings help visitors to reconstruct the original appearance, since the frieze has been painstakingly reconstructed from broken fragments. On the right wall is the adoption of the eight-year-old Lucius Verus and the seventeen-year-old Marcus Aurelius by Antoninus Pius, who had himself been adopted by Emperor Hadrian. Also shown in some detail is the battle between the Romans and the Parthians. The person racing in a chariot through the field of war in the central part of the composition is probably the Emperor. The first part of the frieze on the left includes personifications of places within the Roman Empire which played an important part in the Parthian Wars. In the middle Lucius Verus himself is depicted as Mars, god of war. In another part of the frieze the Emperor is taken up to Olympus in the chariot of the sun god for his final apotheosis. At the end of the room is an attractive octagonal funerary monument from Ephesus, which is unrelated to the frieze and dates from around the birth of Christ.

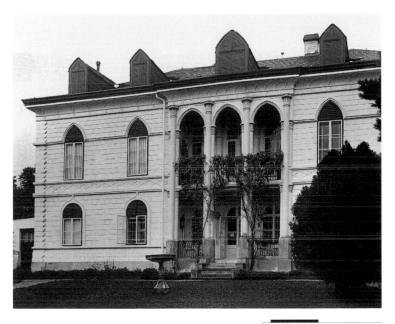

A garden folly built in an eclectic architectural style incorporating Arabian, East Indian and Arabic elements, the Geymüller-Schlössel was built by an unknown architect for the Viennese banker Johann Jakob Geymüller some time after 1808. The summer villa, set in attractive parkland, is run by the Museum of Applied Arts (page 106), and one half of the ground floor is given over to changing exhibitions organized by the museum, while the rest of the building has been redecorated in period style and furnished with Empire and Biedermeier pieces. Most of the furniture was collected by Dr. Franz Sobek, who bought the property in 1945 and lived in it until he gave the house and its contents to the nation in 1965. The museum has supplemented his furnishings with important pieces from its own collection and restored the upholstery and fabrics using authentic textile patterns. Dr. Sobek's collection of over 160 clocks is an added attraction; the earliest are Baroque but most date from the late eighteenth to the mid nineteenth century.

Address

Khevenhüllerstrasse 2,
A-1180 Wien
✆ 4793139

Map reference

⑫

How to get there

TRAM: 41 to end of line, then one stop on 41A bus.

Opening times

1 March to 30 November:
Tue, Wed, Fri, Sat, Sun
10–5. Open on holidays.

Entrance fee

OS30 adults, OS15 senior citizens and students.

Tours

Guided tours Sun
at 3 and by appointment.

Address
Karlsplatz
A-1040 Wien
✆ 5058747

Map reference
⑬

How to get there
U-BAHN: U1, U2 or U4 to
Karlsplatz.
TRAM: 62, 65.

Opening times
Tue to Sun 9–4.30.
Closed 1 January, 1 May &
25 December.

Entrance fee
OS30 adults, OS15 senior
citizens and disabled,
OS10 students and
teachers, OS45 family
ticket.

This 1950s building by Oswald Haerdtl, a pupil of Josef Hoffmann, is somewhat overshadowed by the splendour of the neighbouring Karlskirche, but behind the understated exterior there are many items worth looking at. The exhibits all relate to the history of the city from the Neolithic period to the twentieth century. The permanent displays progress chronologically up the building, but there is generally a temporary exhibition on the ground floor.

The city's history is told through a wide variety of artefacts and works of art. Artistic highlights on the ground floor, which tells the story of Vienna from Neolithic to medieval times, include a number of sandstone sculptures and fourteenth-century stained glass from the Stephansdom. On the first floor, which displays items from the sixteenth, seventeenth and eighteenth centuries, are panoramic views of Vienna; battle scenes from the Turkish wars; eighteenth-century porcelain figures; paintings by Vienna's favourite Baroque artists, Maulbertsch, Troger, Altomonte and Rottmayr; and a number of portraits. The second floor, given over to the nineteenth and twentieth centuries, has some fascinating reconstructed period rooms, including a Napoleonic era salon decorated in the 'Pompeian' style from the Caprara Palace, the poet Grillparzer's apartment decorated in Biedermeier style, and Adolf Loos's strangely cosy sitting room. Two large wooden models show what Vienna looked like before and after the Ring was built. The extensive collection of Biedermeier paintings is dominated by canvases by Waldmüller, Fendi and Amerling, while Hans Makart's pictures give a flavour of prevailing taste during the Ringstrasse era. Austrian art from the turn of the century is represented in canvases by Klimt, Schiele, Gerstl, Moll, Kokoschka and others, and the display of furniture, glass and ceramics from the Wiener Werkstätte forms an interesting counterpart to the collections in the Museum of Applied Art (page 106).

1840

Ferdinand Georg Waldmüller

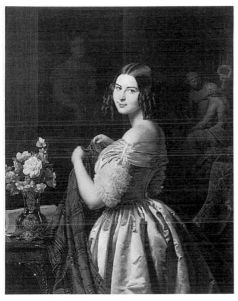

Waldmüller (1793–1865) was the greatest Austrian artist of the Biedermeier era. He began his career as a painter of portrait miniatures, and never lost his ability to capture fine detail in his canvases. Later, as a professor at the Viennese Academy, he proclaimed that the study of nature rather than the 'ideal' art of previous eras should provide the basis for painting, and this belief is particularly evident in his landscapes, which possess a sparkling clarity and wealth of detail. Yet in practice he was not entirely consistent with his own pronouncements. When he turned to painting peasant life he tended to prettify it and censor unpleasant details. Similarly, although Waldmüller always aimed for an exact rendering of his sitters' features, his portraits were tempered with the type of classicism seen in works by Ingres. Here, for example, an unnamed woman poses with studied grace in front of a marble statue group; the smoothness of surface, the apparent luxury of the interior and the sheen of the satin dress are all characteristics that can be seen in the work of the French master. There is a sheer delight in the loveliness of the subject, which like so many Biedermeier pictures hovers halfway between straightforward portraiture and genre painting. The vase of flowers on the table pays tribute to the Viennese love of floral decoration, as well as to Waldmüller's skill as a still life painter.

Pallas Athene

1898

Gustav Klimt

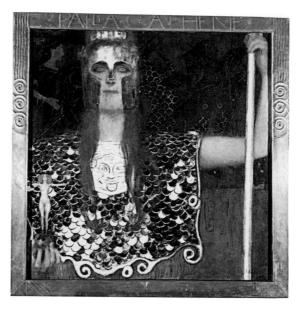

In Greek mythology Pallas Athene was the daughter of Zeus, from whose head she sprang fully armed. Although she is usually represented in painting as a war goddess clad in armour and holding a spear, she was also a patroness of the arts. She was a particular favourite with avant-garde artists who belonged to the Munich and Vienna Secession, as she was seen as a warrior champion of just causes and a promoter of wisdom. The fact that the portal of the Vienna Secession building (page 120) is decorated with Medusa heads is an indirect reference to her, since according to legend Perseus presented her with the head of Medusa after she helped him slay the monster.

The proud and immobile Pallas Athene, clad in helmet and breastplate as portrayed by Klimt (1862–1918), confronts the onlooker with her hypnotic stare; it is almost as though she is barring the specatator's way into the picture space. She holds in her right hand a tiny statuette of a naked woman. In Klimt's personal repertoire of symbols nude figures with outstretched arms often represented female sexuality. The background frieze is based on late Archaic Greek vase painting and Athenian black-figure work. The metal frame, which perfectly complements the picture, was designed by the artist and executed by his brother Georg, who was also responsible for the bronze entrance doors to the Secession building.

Self-portrait with Spread-out Fingers

1911

Egon Schiele

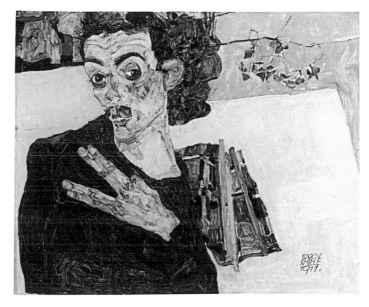

The art of Egon Schiele (1890–1918) was heavily autobiographical, and self-portraits featured largely in his output. He was only twenty-one when he produced this startling image of vulnerability, presenting himself as though flattened against an abstract patterned background. His hand, placed against his chest, seems to be trying to protect it, but the highly artificial gesture is quite inexplicable, although it reappears in other works. A black vase in the shape of a profile head is set against Schiele's own face, making him resemble a Janus figure. It is possible that Schiele adopted the device from a self-portrait by Gauguin, which he could have seen in reproduction, in which the artist juxtaposed his own image with a ceramic tobacco jar in the shape of a head.

If the overall impression is one of a hunted man, Schiele had some reason to feel persecuted at the time. In 1911 he had met the artist's model Wally Neuzil and had gone to live with her in the small town of Krumau. However, the intolerance of the conservative provincial community, which disapproved of an artist living openly with his model, had forced him back to Vienna and deepened his perception of himself as an outsider. This notion was reinforced in the following year when Schiele was arrested and put in prison for exhibiting an erotic drawing in a place where children might see it. The result was a further series of self-portraits as a prisoner.

Address
Michaelerplatz 1
A-1010 Wien
✆ 521770

Map reference
⑭

How to get there
U-Bahn: U1 or U3 to
Stephansplatz, or U2 to
Marihilferstrasse.
Tram: 1, 2, D, J, 52, 58.

Opening times and entrance fees
See individual collections

This vast complex, consisting of ten major buildings, is wedged between the Ring and the inner city. In addition to the offices of the Austrian President, it also houses the former Imperial State Apartments, the Winter Riding School, the National Library, and the Burgkapelle. The major architectural styles of seven centuries can be seen here, from Gothic to nineteenth-century historicism. Most visitors entering from the Heldenplatz face the seventeenth-century range of buildings, with the newest extension, or Neue Burg, on their right – this was not finished until 1913. The oldest parts lie beyond. They include the Schweizerhof (Swiss courtyard) which is entered through a Renaissance gateway; the courtyard named In der Burg, once a tiltyard; and the Imperial stables, originally an arcaded Renaissance palace. The side of the Hofburg that looks out over the Michaelerplatz is particularly impressive. It was constructed in the late nineteenth century following earlier plans by J. E. Fischer von Erlach and features two mammoth fountains symbolizing power on land and at sea.

THE HOFBURG: IMPERIAL STATE APARTMENTS

Guided tours take visitors through the state apartments in the eighteenth-century Chancellery wing which were once occupied by Emperor Franz Joseph and the Empress Elisabeth, and by Tsar Alexander I when he was attending the Congress of Vienna in 1815. Red, white and gold make up the prevailing decorative scheme and here the overall impression is one of slightly dusty grandeur. Some of the rooms are enlivened by Brussels tapestries and portraits of the Imperial family, including Winterhalter's famous likeness of the Empress with stars in her hair. In the Emperor's rooms one can see the lectern at which he stood while receiving visitors; his spartan bedroom; and the audience hall with frescoes by Peter Krafft showing scenes from the life of Franz I. The atmosphere in the Empress's rooms is more intimate. The wall bars and rings on which she practised her daily gymnastics strike an incongruous note, and it is surprising to find no bed in her bedroom – her portable iron bedstead was removed each morning. A statue of the Empress in an antechamber leads to Alexander's apartments, which are more richly decorated.

Address
Michaelerplatz 1
A-1010 Wien
℗ 5875554515

Map reference
(15)

How to get there
U-BAHN: U1 or U3 to Stephansplatz, or U2 to Mariahilferstrasse.
TRAM: 1, 2, D, J, 52, 58.
Enter through the Domed Chamber inside the Michaelerplatz entrance.

Opening times
Daily Mon to Sat 8.30–12, 12.30–4.

Entrance fee
OS70 adults, OS35 students and pensioners.

Tours
Compulsory tours

WELTLICHE UND GEISTLICHE SCHATZKAMMER

(THE SECULAR AND ECCLESIASTICAL TREASURIES)

Address
Hofburg Schweizerhof
A-1010 Wien
✆ 521770

Map reference
(16)

How to get there
U-BAHN: U3 to Herrengasse,
or U2 to Mariahilferstrasse.
TRAM: 1, 2, D, J, 52, 58.
Entrance is in the
Schweizerhof.

Opening times
Mon, Wed to Sun 10–6;
24 & 31 December: 10–1.
Closed 1 May, 1 November,
25 December.

Entrance fee
OS60 adults,
OS30 concessions.

A rich assembly of treasures gathered together by members of the Habsburg family is displayed in the inner sanctum of the oldest part of the Hofburg. Among the insignia of the Holy Roman Empire are a crown made in the second half of the tenth century; an eleventh-century relic of the Holy Cross; a lance incorporating a nail said to have come from the Cross; a thirteenth-century orb and a Carolingian gospel book on which the Emperor swore his oath. The more legendary items include a fourth-century agate chalice, once thought to be the Holy Grail, and a 'unicorn's horn' – in reality a narwhal's tooth. In the section devoted to the Burgundian treasures is the Treasure of the Order of the Golden Fleece. The Geistliche Schatzkammer, or Sacred Treasury, contains showcases bulging with reliquaries (one of which is said to contain a tooth from St. Peter), monstrances, carvings, statuettes and other religious items spanning the twelfth to the nineteenth centuries.

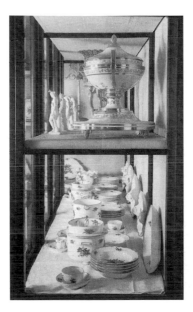

THE HOFBURG: IMPERIAL TABLEWARE

This is the repository of ceremonial and every-day tableware that once graced the Imperial table but is now no longer used, even for state banquets. It is hard to believe that the Habsburgs dined off gold plates, but an entire gilded silver dinner service with 140 place settings bears witness to the fact. The service is displayed here with other dazzling items, such as a chased gilt-bronze hundred-foot long centrepiece and accompanying candelabras replete with cupids and animals. Less ostentatious but more appealing is the 1756 green Sèvres dinner service Louis XV gave to Maria Theresia. Another diplomatic gift was the 'English service' which Queen Victoria presented to Emperor Franz Joseph. Among the other exhibits, there is a lovely portable tea service with a samovar which was made in Paris for the Empress Elisabeth Christine, wife of Karl VI. A 'Gothic' dessert service made by the Wiener Porzellan-Manufactur shows ancestral Habsburgs and family palaces. In the last of the six rooms devoted to the collection is the jug and salver which the Emperor and Empress used to wash the feet of twelve poor people on Maundy Thursday.

Address
Michaelerplatz 1
Hofburg
A-1010 Wien
© 523424099

Map reference
(1/)

How to get there
U-BAHN: U1 or U3 to
Stephansplatz, or U2 to
Mariahilferstrasse.
TRAM: 1, 2, D, J, 52, 58.
Enter through the Domed
Chamber inside the
Michaelerplatz entrance.

Opening times
Daily 9–5.

Entrance fee
OS60 adults,
OS30 concessions,

ÖSTERREICHISCHE NATIONALBIBLIOTHEK
(AUSTRIAN NATIONAL LIBRARY)
Built 1722–35

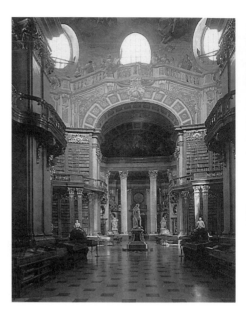

Address
Josefsplatz 1
A-1010 Wien
℡ 53410397

Map reference
⑱

How to get there
U-BAHN: U1 or U3 to
Stephansplatz, U3 to
Herrengasse, or U2 to
Mariahilferstrasse.
TRAM: 1, 2, D, J.

Opening times
Prunksaal: May to October:
Mon to Sat 10–4; Tue 10–6;
Sun and public holidays
10–1. November to April:
Mon to Sat 11–12.
Augustinerlesesaal: by
appointment only.

The great showpiece of this major library,
designed by Johann Bernard Fischer von Erlach
and completed by his son Joseph Emanuel, is
the *Prunksaal* or Grand Hall, a magnificent
example of High Baroque pomp which occu-
pies most of the length of the building. It is this
interior, together with the Augustinerlesesaal
(Augustinian Reading Room) decorated by
Johann Bergl, that constitutes the main attraction
for visitors. The hall extends over two storeys,
with marble columns, carved and gilded shelv-
ing and statues by Paul and Peter Strudel con-
tributing to the impression of grandeur. The
oval cupola is decorated with frescoes by Daniel
Gran dating from 1730. These depict an alle-
gory of fame, in which Karl VI plays a central
role. His marble statue is placed immediately
below. In the long wings on either side of the
dome, ceiling paintings illustrate the themes of
war and peace. The 16000 leather-bound vol-
umes in the bookcases originally belonged to
Prince Eugene, but were bought on his death by
Joseph II. Temporary exhibitions drawn from the
vast collections of manuscripts, incunabula and
printed books are organized all year round.

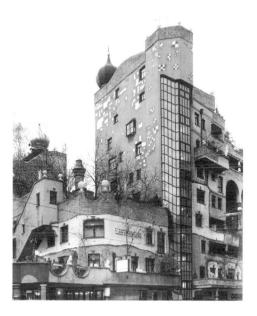

When the city authorities commissioned Friedensreich Hundertwasser (born 1928) to design a residential complex of fifty apartments the result was one of Vienna's most extraordinary edifices. Bands of riotous colour and mosaics snake their way around a building in which not one straight line or sharp corner can be found. In a playful spirit the architect crowned the towers with two golden onion domes, and here and there kitsch statuettes perch on gallery walls. Hundertwasser, who places great stress on his aim of uniting man with nature, has made sure that plenty of space is given to 'tree tenants', whom he sees as 'ambassadors of the forests in the city', and branches and leaves wave out from windows and balconies. There are also tantalizing glimpses of roof gardens, which provide green oases in the midst of this crazy and colourful patchwork. Unfortunately, but understandably, the residents no longer open their apartments to the public, who must be content to see the complex from the outside, or to visit the shop and snack bar.

Address
Löwengasse/Kegelgasse
A-1030 Wien
✆ /136093

Map reference
⑲

How to get there
U-BAHN: U3 or U4 to Wien Mitte/Landstrasse.
TRAM: O.
BUS: 75A.

Opening times
Not open to the public

⊛ KARLSKIRCHE
(CHURCH OF ST. CHARLES BORROMEO)
Built 1714–37

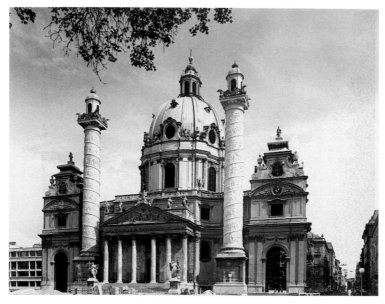

Address
Karlsplatz 1
A-1040 Vienna
✆ 5046187

Map reference
⑳

How to get there
U-BAHN: U1, U2 or U4 to
Karlsplatz.
TRAM: D, 1, 2.

Opening times
Mon to Fri 7.30–7; Sat 8–7;
Sun 9–7.

At the height of Vienna's plague epidemic in
1713, Emperor Karl VI vowed that he would
build a church dedicated to Charles Borromeo,
a patron saint of plague. The following year he
announced a competition, which was won by
Johann Bernard Fischer von Erlach, although the
building was not completed until after Johann
Bernard's death by his son Josef Emmanuel.
The result is a richly eclectic masterpiece of
Baroque architecture, which features a gigantic
dome; a portico modelled on a Greek temple;
two minaret-like columns, which were actually
inspired by Trajan's Column in Rome and dec-
orated with sculpted reliefs showing episodes
from the life of St. Charles Borromeo; and two
gatehouses resembling Chinese pavilions. The
light and airy interior contains altarpieces by
Daniel Gran and Martino Altomonte and an
extraodinary stucco high altar showing St.
Charles Borromeo being assumed into heaven
while adoring angels look on. But the crowning
glory is the dome fresco, full of hectic move-
ment, depicting the apotheosis of St. Charles
Borromeo – a late work by the artist Johann
Michael Rottmayr.

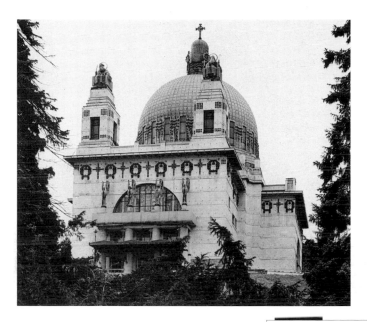

One of the most important Secessionist buildings in Vienna, the Church of St. Leopold (popularly known as Kirche am Steinhof) was designed by Otto Wagner. Other leading avant-garde artists of the day contributed to the interior. The church commands an imposing position on top of a hill in the grounds of a sanatorium for the mentally ill, and was designed to function as a place of worship for the inmates. This led to certain clever interior modifications: the benches are curved so as to prevent injury, and there is a sloping tiled floor for easy cleaning. Although the building was governed by practical considerations, it was also ambitious in design, consciously invoking grand Baroque schemes with its large central dome and portico surmounted by monumental angels, while reworking these references in a thoroughly modern idiom. The inside of the dome, with its latticework of gold on white, creates a wonderful impression of airiness. Kolomon Moser's stained glass windows and Remigius Geyling's mosaics add the only other decorative elements in an otherwise spare interior.

Address
Baumgartner Höhe 1
A-1140 Wien
© 9490602391

Map reference
㉑

How to get there
Bus: 48A.

Opening times
Sat 3–5 or by appointment.

Begun 1114

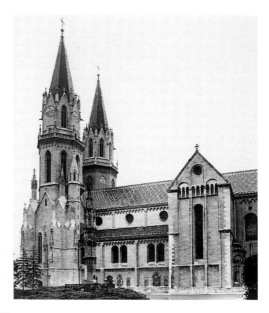

Address
Stift Klosterneuburg
A-3400
✆ 02243 6210212

Map reference
㉒

How to get there
U-BAHN: U4 to Heiligenstadt,
then train or 239 bus to
Klosterneuburg.

Opening times
1 May to 15 November: Mon
to Sat 9–12 and 1.30–4.30;
16 November to 30 April:
daily 1.30–4.30.

Entrance fee
OS40.

Tours
Compulsory guided tours in
German and English.

About ten kilometres from the centre of Vienna,
the monastery complex of Klosterneuburg is
situated to the north-east of the Vienna woods,
overlooking the Danube. The Abbey was found-
ed in the twelfth century by Margrave Leopold
III. According to a rather fanciful legend, he
was standing on the balcony of his castle on his
wedding day when a gust of wind blew his wife's
veil away. Nine years later when he was out
hunting, Leopold was attracted by a brilliant
light emanating from the veil, which had become
tangled up in a bush. A vision of the Virgin Mary
told him to build a convent on this spot, and
this became the Abbey of Klosterneuburg. The
Romanesque exterior of the church hides a mag-
nificent Baroque interior. The convent build-
ing itself, topped by outsized crowns, is also
Baroque. Its surprisingly lavish apartments were
created for Karl VI who intended to make his
home here but in fact spent no more than one
night under its roof. The complex was only par-
tially completed. The gallery contains an excel-
lent selection of Austrian paintings from the
fifteenth to the nineteenth centuries.

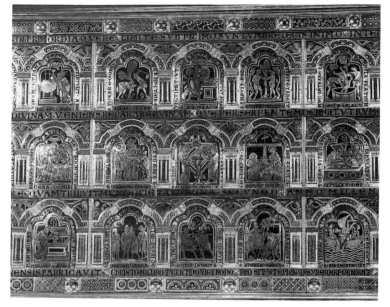

In the Abbey's thirteenth-century cloister is a small chapel containing one of its most unusual treasures: an altarpiece consisting of fifty-one enamelled and gilded plaques of which a detail is shown above. Originally they decorated the pulpit in the church, but after they were saved from a fire in 1330 by being doused with wine, they were reassembled to form a winged altarpiece and six more plaques were added to the original forty-five. Despite this and subsequent restorations, the altarpiece is considered to be the greatest surviving example of the medieval goldsmith's art. The plaques were created by Nicholas of Verdun (c. 1130–c. 1205) and are arranged in three rows symbolizing the three epochs described in the Bible. The upper row shows the Old Testament epoch before God declared the Holy Law to Moses; the middle row relates to the era of fulfilment and redemption through Christ; and the bottom row returns to the Old Testament and the epoch after the Law was given to Moses. Events in the Old Testament are shown to prefigure and explain events in the life of Christ, each plaque relating symbolically to the one above and below it. For example, the passage through the Red Sea in the top row is seen as a parable of the Christening ceremony and is related to the Baptism of Christ shown in the middle row and the depiction of the sea resting on twelve cows in the court of Solomon in the bottom row. The enamelled shrine above the altar contains the bones of Leopold III.

Address
Untere Weissgerberstrasse
13
A-1030 Wien
✆ 7120491

Map reference
㉓

How to get there
U-BAHN: U3 or U4 to Wien-
Mitte/Landstrasse.
TRAM: N.

Opening times
Daily 10–7.

Entrance fee
OS70 adults,
OS40 concessions,
children under 12 free.

The Kunsthaus Wien, designed by Friedensreich Hundertwasser (born 1928), is a highly eccentric and enjoyable place to visit. Hundertwasser sees his building as 'an adventure of modern times, a journey into the land of creative architecture, a melody for the feet and eyes'; and the mosaic-clad corridors cooled by fountains, the trees leaning out of windows at odd angles and the irregular floor do lend it an undeniable charm. Apart from raising revenue to keep the centre open, the aim is to make the visitor feel at home, so there is a restaurant, a courtyard café and a museum shop filled with delectable craft objects. The top floor is given over to changing shows of modern art from all over the world. Recent exhibitions have featured the work of Tinguely, Matta, Warhol, Christo, Miró, Le Corbusier and photographers Annie Leibovitz and Robert Mapplethorpe. The first floor contains a permanent retrospective collection of Hundertwasser's work, tracing its progress from juvenilia to the present day.

There is a markedly didactic content to his paintings and buildings, which, by the artist's admission, seek to promote peace, happiness and harmony with nature. Visitors are left in no doubt about his philosophy, since the canvases, architectural models and graphics are accompanied by numerous aphorisms, which are sometimes bombastic to the point of absurdity. Hundertwasser would like the Kunsthaus Wien to be 'a bastion against the dictatorship of the straight line, the ruler and the t-square, a bridgehead against the grid system and the chaos of the absurd'; and he applies these ideas with a ruthless rigour to his art, in which pattern, curves and spirals (which he sees as a symbol of creation) run riot. In their decorative content the pictures embody an essentially Viennese obsession with ornament, and pay tribute to the art of Hundertwasser's predecessors Gustav Klimt and Egon Schiele.

The Collections

The main building of the Kunsthistorisches Museum contains five collections: a gallery of paintings, which occupies the whole of the first floor; the sculpture and applied arts collection, which takes up the left wing of the ground floor; the art of Ancient Egypt, which is housed in special ground floor rooms to the right of the entrance; and works from Greece, Rome and the Near East, also in the right-hand wing of the ground floor. On the second floor is the Coin Cabinet and a study collection usually accessible only to scholars.

For many visitors the chief attraction will be the picture gallery. As the former private collection of the Habsburgs it has very particular strengths and weaknesses. It was not formed to present a balanced view of art historical periods, but reflects the personal tastes of its founders as well as links with those countries that the Habsburg dynasty ruled for over 500 years. One of the great glories of the collection is the Bruegel room, containing twelve authenticated paintings out of only about forty existing works by Pieter Bruegel the Elder. An excellent selection of pictures by other early Netherlandish and German artists includes works by Hans Memling, Rogier van der Weyden and Lucas Cranach the Elder. The gallery is particularly rich in sixteenth- and seventeenth-century paintings from Flanders and Venice, with two rooms devoted to Rubens and one to Titian. There is also a small but significant collection of Velázquez portraits of the Spanish Habsburgs. Yet there are few paintings from France and England, and although there are some wonderful examples from seventeenth-century Holland, the collection in that area is not large.

It would certainly take more than a day to see everything in the museum, and visitors are sure to welcome the refreshment on offer in the elegant café on the first floor beneath the cupola. This is also a particularly good point from which to admire some of the fine architectural detail of the building while resting your feet.

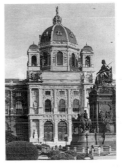

Address
Maria-Theresien-Platz
A-1010 Wien
✆ 521770

Map reference
㉔

How to get there
U-Bahn: U2 or U3 to Volkstheater.
Trams: 1, 2 to Burgring.

Opening times
Picture Gallery, Collection of Sculpture and Decorative Arts, Egyptian and Near Eastern Collection, Greek and Roman Antiquities and Coin Cabinet: Tues to Sun 10–6, Picture Gallery only Thur 10–9.

Entrance fee
ÖS45, ÖS30 concessions.

Tours
Daily tours of highlights in English at 11 and 3, in German at 10.30.

The Building

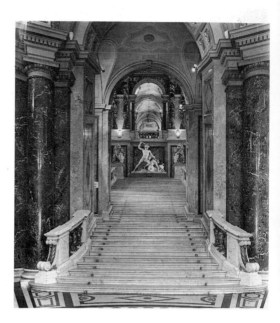

In the 1860s the creation of the Ringstrasse freed the space opposite the Hofburg for two large museums. One was to be dedicated to the Imperial fine arts collection and the other to natural history. Externally, the two museums. One was to be dedicated to the Imperial fine arts collection and the other to natural history. Externally, the two museums are almost mirror images of each other, but the internal decoration and sculptural details relate to their respective collections. The architects Karl von Hasenauer and Gottfried Semper worked on both buildings, and no expense was spared during the period of construction, which lasted from 1871 until 1891.

The exterior of the Kunsthistorisches Museum is decorated with sculptures symbolizing the different branches of art and the great artists and philosophers of different eras. The foremost artists of the day helped to create an interior of overwhelming grandeur, which luckily survived heavy bombing during World War Two. From the domed vestibule the visitor ascends an imposing marble staircase dominated by Canova's sculpture of *Theseus and the Centaur* on the landing. The subject of the ceiling fresco by Michael Munkacsy is *The Apotheosis of the Renaissance*; the lunettes depicting famous artists were the work of Hans Makart. The spandrel pictures between the marble columns, showing the evolution of art, were painted by Ernst and Gustav Klimt and Franz Matsch. In the top hall the cupola is decorated with relief medallions portraying the great Habsburg collectors, while a large relief by Rudolf Weyr shows the artists who worked for the Habsburg princes.

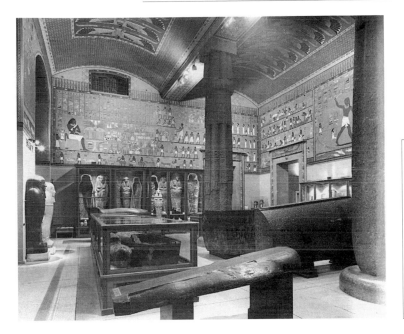

Immediately to the right of the entrance hall is the Egyptian and Near Eastern Collection. Because the rooms were specially designed for their contents they are decorated with Egyptian friezes and borders. Room I (illustrated above) even incorporates Egyptian eighteenth-dynasty bundled papyrus stalk columns as part of the overall structure, and a complete funerary chapel may been seen in room VIA. As with the other areas within the museum, the core collection was assembled by the Habsburgs: Archduke Ferdinand Maximilian (who later met an unfortunate end as Maximilian of Mexico) was a particularly avid collector. Archaeological digs in the twentieth century have also added considerably to the museum's holdings, particularly Hermann Junker's work around the pyramids of Giza in the 1920s and Eduard Glaser's excavations in South Arabia.

The exhibits are arranged thematically. Room I contains items relating to the cult of the dead, such as sarcophagi, canopic jars, coffins and mummies. Most of the extant objects from Ancient Egypt are funerary statues or items produced for the dead; the little blue pottery hippopotamus and the small shabti figurines (which were supposed to act as workers in the afterlife) were found in tombs. In Room II are objects from Arabia, and pride of place goes to a tile relief of a lion from the Babylonian Ishtar Gate. Room III illustrates the cult of animals and contains mummified sacred beasts and statues of animal gods; Rooms IV and VI house everyday items such as furniture, clothes and jewellery; and Rooms V, VII and VIII are devoted to works of art from the Old, Middle and New Kingdoms.

The Collection of Greek and Roman Antiquities

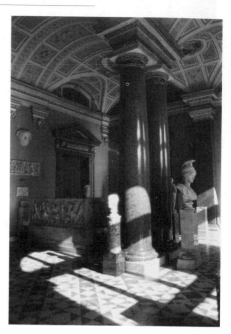

Just past the Egyptian section on the ground floor, the museum's collection of Classical antiquities is housed in a series of specially designed rooms, the grandest of which are decorated with inlaid marble and Classically inspired friezes. The display is more wide-ranging than the departmental title would suggest, covering a period from the Bronze Age up to early Christianity, but the main focus is on the sculpture, vases, bronzes, glass, jewellery and mosaics of ancient Greece and Rome. Archaeological finds from Ephesus and Samothrace are displayed separately and can be seen on the other side of the Ring in the Ephesos Museum in the Neue Burg (see page 49).

One of the most striking exhibits is a bronze statue of a youth which was found at Magdalensberg, although it is actually a sixteenth-century cast after a Roman original. The Theseus mosaic set into the floor of the main display room is another Austrian find of outstanding beauty; it came from a villa near Salzburg. On a smaller scale, the little silver statue of the front part of a centaur, which may have formed part of a drinking horn, is a masterpiece of virtuosity. Among the cameos, the Gemma Augustea, bearing an allegorical representation of Augustus as Jupiter and the victory of the Romans over the Dalmatians, is a remarkable piece of craftsmanship; it was among Emperor Rudolph II's prize possessions. In one of the final rooms is the gold treasure from Nagyszentmiklos in present-day Rumania, an astounding collection of twenty-three finely crafted golden vessels.

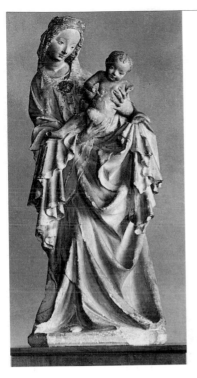

The museum's collection of sculpture and decorative arts occupies the whole left wing of the ground floor. During the Renaissance it was the custom, particularly among Germanic rulers, to assemble *Kunstkammer*, or Chambers of Marvels. These included not only works of art but also curios such as scientific instruments, examples of the goldsmith's craft, small devotional articles, figurines, gems and other items of a rare or exotic nature that had some bearing on the human quest to understand the universe. The present display is formed around a core of such objects gathered together by Archduke Ferdinand II, Emperor Rudolph II and Archduke Leopold Wilhelm, and it retains something of the feel of their collections. However, besides the type of small exquisite piece that would have been found in a cabinet of curiosities, it also includes a number of large-scale sculptures such as the Krumau Madonna of *c*. 1390–1400 (illustrated above). This sandstone piece, probably produced in Prague, exemplifies the delicate International Gothic style characterized by fluidity of lines, refinement and elegance. It is a particularly tender depiction of a mother and child in which the figure of Christ, who would originally have been playing with an apple, is set against the flowing draperies of his mother's robe while she looks on with an expression of maternal adoration. Perhaps the best-known item from the collection, Cellini's famous *Saltcellar*, is on display in the picture galleries upstairs (page 99).

Spring Landscape (May)

1587

Lucas van Valckenborch

This is one a series of large paintings of the seasons in the Kunsthistorisches Museum by the Flemish painter Lucas van Valckenborch (c. 1535–97). The artist originally painted twelve pictures for the Archduke Matthias, but only seven survive, of which five are in the museum. Although it contains both elegant and grotesque figures (the jester in the foreground makes a comic contrast with the loving couples), this work has a more aristocratic flavour than the other three, which are peopled with peasants. July or August shows them harvesting; in September they make wine; in October they celebrate and in January or February they cart fuel through the snow. May is the month of love, and this lovely landscape is crowded with vignettes of gallantry and pleasure: in the foreground women gather flowers for a garland, and a picnic and dancing are shown in the middle distance. There are two mazes, one in an island in the middle of the river, which contains a gazebo, and another in the garden, which has at its centre a fountain surmounted by a water sprite. In the background is a fantasy landscape which nonetheless includes some recognizable and accurately rendered features such as the belfry of St. Gundula and the Archduke's palace in Brussels, in front of which a tournament is taking place.

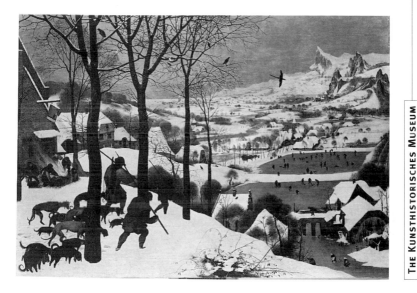

In 1565 the Flemish painter Pieter Bruegel the Elder (1525/30–1569) painted a series of six pictures showing the progress of the seasons and the rural activities associated with them. The division of the year into six rather than four was an ancient one, with roots in classical antiquity. Three out of the five surviving paintings in this series are in the Kunsthistorisches Museum – the other two are *Dark Days* and *The Return of the Herd*. The final canvas (shown above) represents deepest winter. It is dusk, and the hunters and their pack of hounds are returning to their village bearing meagre spoils. To their left, a group of figures outside an inn are slaughtering a pig, and in the background the villagers skate on a frozen pond. The cold crisp air is suggested by a reduced colour scheme of browns, greens and white and the clarity of the background detail. The bold use of the diagonally receding line of trees to lead the eye into the picture is remarkably innovative.

The series was commissioned by the Brussels banker Nicholaes Jonghelinck, but was later presented to the Spanish regent of the Netherlands, Archduke Ernst, whose brother Rudolph II eventually gained possession of the paintings. The Kunsthistorisches Museum has the largest collection of Bruegels of any gallery in the world.

The Peasant Wedding

c. 1586/69

Pieter Bruegel the Elder

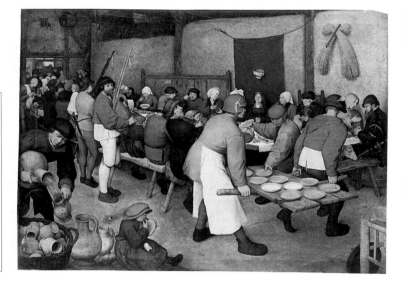

This is one of the much loved subject paintings of peasant life which contributed to the artist's fame. Although the event has its comic moments, Bruegel (1525/30–1569) portrays the characters with affection and sympathy, never descending into simple caricature. The wedding party takes place in a threshing barn, and bales of hay are stacked up in the background. The bride is sitting in front of a green cloth secured by pitchforks and above her head is a paper crown. In keeping with Flemish tradition she can neither speak nor eat at the meal, and her bridegroom is not allowed to attend the feast at all – he will join her on the wedding night. The notary who has drawn up the marriage contract is wearing a black beret and sitting in a wooden chair. Next to him a monk converses with the lord of the manor, dressed in Spanish fashion, who sits at the end of the table. It is he who has paid for the beer which his servant is distributing in the foreground. Two men carry in the bowls of simple food coloured with saffron on a makeshift tray made from an old door, while musicians play the bagpipes. We feel drawn into the picture by the strong diagonal leading back from the food carriers and along the table into the distance.

Near this picture hangs near another scene of celebration which forms an interesting counterpart to it. *Peasant Dance* shows couples performing a traditional dance at the opening of a village fair.

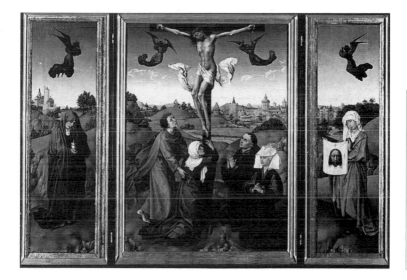

With Jan van Eyck, Rogier van der Weyden (1399/1400–1464) was the most important Flemish painter of the mid fifteenth century. Although many details of his life remain obscure, it is known that he was official painter to the city of Brussels and that he spent most of his life there apart from a visit to Italy in 1450. The whole dramatic episode of this triptych is set against a continuous landscape with a distant view of a fanciful Flemish city complete with towers, domes and a monastery. In the central panel Christ on the cross is mourned by John the Baptist and the Virgin Mary, while two donors who would have paid for the picture worship on the right. Their identity is unknown, but they wear the fur-trimmed garments of Rogier's time and appear to be of equal rank; it has been suggested that they may come from the monastery in the background. Mary Magdalene is shown in the left panel and St. Veronica is portrayed in the right. Perhaps the most remarkable feature of the painting – and Rogier's work in general – is the intensity of its emotional expression. The artist has not hesitated to show the ugliness of grief as Mary weeps uncontrollably at the foot of the cross. Yet this naturalism is combined with a high degree of stylization in Christ's fluttering draperies and the decorative folds in the robes of the mourning figures.

The Altarpiece of the Archangel Michael

c. 1510

Gerard David

The Book of Revelation describes how St. Michael and his angels waged war against Satan (personified as a dragon) and his fallen angels. The subject seems to have been a favourite among Flemish artists, and David (*c.* 1460–1523) displays obvious relish in his depiction of St. Michael trampling a horrendous creature underfoot – the fact that the creature has seven heads might be an allegorical reference to the seven deadly sins. In the background the rebel angels fall into a chasm, while the Almighty looks out from a gap in the clouds. The wings of the altarpiece show St. Jerome (recognizable because of his Cardinal's hat) and St. Anthony of Padua, while on the reverse of the wings are St. Sebastian and an unidentified female saint with a boy.

Christ Carrying the Cross

c. 1480

Hieronymus Bosch

This small panel by Bosch (*c.* 1450–1516) is the left wing of a lost altarpiece whose central panel would have shown the Crucifixion. At the top, Christ stumbles on the road to Calvary; below, the good thief on the right seeks absolution for his sins while the bad thief on the left goes towards his execution howling. The two bands of the composition are cleverly linked by the tree trunk which snakes its way from the foreground to the top of the picture. On the back of the panel (which can be revealed if an obliging gallery attendant swivels it round) is a monochrome picture of a naked child with a walking frame and a windmill. He must surely represent humankind in its innocent state.

After 1484

Geertgen tot Sint Jans

Geertgen tot Sint Jans (*c.*1460/5–*c.*1490/95) was the foremost Dutch master of his time. He lived with the Knights of St. John in Haarlem – hence his adopted surname, which means 'Little Gerard of the Brethren of St. John'. It was quite common for artists to be given board and lodging by religious orders in exchange for their work, and this panel was the right-hand wing of a large altarpiece that Geertgen painted for the monastery church. Another panel, *The Lamentation*, also in the Kunsthistorisches Museum, was painted for the same altarpiece.

The picture was intended to celebrate the Sultan of Turkey's return of the relics of St. John the Baptist to the Order of St. John at Haarlem in 1484, and this panel relates a number of episodes in the legend of the relics, spanning several centuries. In the background St. John's body and head are buried separately, while in the foreground the miracle-working remains are exhumed on the orders of Emperor Julian the Apostate in AD 362; the Emperor stands with his courtly retinue on the right. In the middle distance is an episode from the thirteenth century, in which monks dressed as Knights of St. John rescue some of the unburnt bones and deliver them to the Order at St. Jean d'Acre. There are some fine likenesses of Geertgen's contemporaries among the monks, while the workmen burning the bones are caricatures worthy of Bosch.

The Fall of Man and the Lamentation

c. 1470/75

Hugo van der Goes

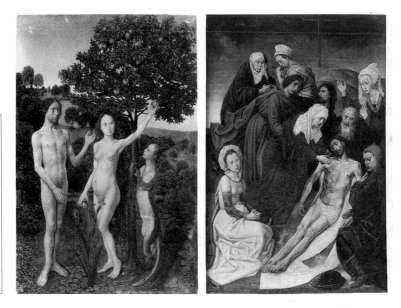

Hugo van der Goes (*c.* 1440–82) was born in Ghent and was mainly active there and in Brussels. As is often the case with early Flemish painters, the precise chronology of his life and work is not documented, although it is known that he was Dean of the Painters' Guild in Brussels and that he retired to a monastery suffering from mental illness before his early death. His fame rests securely on the *Portinari Altarpiece* in the Uffizi Gallery in Florence, and all other attributions to him are based on comparison with this work.

Two very different pictures make up this small diptych, which illustrates the Catholic notion that humanity was estranged from God through Adam and Eve's sin, and that it was only through the death of Christ that a reconciliation could take place. On the left, Adam and Eve stand within an almost microscopically detailed landscape in which every leaf, flower and blade of grass is delineated with razor-sharp clarity, and the serpent tempting Eve looks convincingly reptilian. On the right the deposition from the cross takes place against a barren hill of Golgotha, and it is the dramatic intensity of the moment, expressed through the sweeping diagonal of the crowded composition and the expansive gestures of the figures, that holds our attention. This panel makes an interesting comparison with Rogier van der Weyden's *Crucifixion* which hangs nearby (page 75); the portrayal of agitation and grief here must owe something to the older master.

1511

Albrecht Dürer

THE KUNSTHISTORISCHES MUSEUM

This vibrant altarpiece was painted not long after the German artist Dürer (1471–1528) returned from a trip to Venice, and instead of conforming to the German triptych pattern of a central panel flanked by side wings the artist chose to follow the Italian model of a single panel set within an elaborate frame. The work was commissioned by Matthaus Landauer, a wealthy Nuremburg merchant who had founded a home for twelve elderly craftsman. Landauer intended it for the chapel which was dedicated to the Trinity and All Saints, and this determined the subject of the painting, which shows the Holy Trinity of God the Father, Christ on the Cross and the dove of the Holy Ghost being adored by an assembled company of heavenly and earthly beings. On either side of the cross, angels bear instruments of the Passion. Below them on the left are holy virgins and female martyrs, many of whom can be identified: the Virgin Mary is at the front and behind her are St. Catherine with her wheel, St. Dorothy with her basket of flowers, St. Barbara bearing a chalice and St. Agnes carrying a lamb. On the right, their male counterparts include St. John the Baptist, Moses bearing the Commandments and King David with his harp. Below these figures are two groups of Christian believers, ecclesiastical on the left and secular on the right. The donor, with his long hair and a fur collar, kneels between a cardinal and a monk, and Dürer has included his own self-portrait in the bottom right-hand corner.

Portrait of a Young Venetian Lady

1505

Albrecht Dürer

The greatest painter and graphic artist of Renaissance Germany, Albrecht Dürer (1471–1528) was born in Nuremberg, but travelled widely throughout Europe, assimilating the new humanist learning and painterly innovations. Two of his most significant journeys were to Venice: he went there for the first time in 1494–95, when he made an attractive series of Alpine watercolours, and on a second occasion in 1505–7, when he looked closely at the work of his Venetian contemporaries. This picture of an unknown sitter was painted during the second trip, and it contains many echoes of Venetian portraiture, particularly in its simple bust-length presentation. Both the young woman's dress and her hair, which is drawn into a net on the back of the head with curling strands framing her face, are Venetian in style. Although Dürer was highly impressed by the rich colours used by artists like Giovanni Bellini – this can be seen in works such as *The Landauer Altar* (page 79) – here he chose a relatively limited range of golds, browns, creams and blacks to achieve a wonderfully subtle effect.

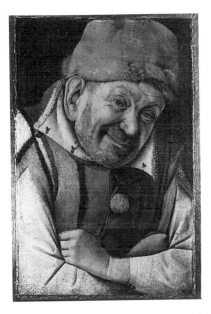

Jean Fouquet (*c.* 1420–81) was the leading painter in France in the fifteenth century. Although he spent most of his working life in Tours, between 1443 and 1447 he travelled to Italy, where he painted a portrait of Pope Eugenius IV in Rome, which has now been lost. On his way to the Holy City he stayed at Ferrara, and it was while he was there that he completed this portrait of the Ferrarese court jester. It is an extraordinary work for the direct manner in which the old man is portrayed with his reddened eyes, wrinkles and stubble. Before the painting's authorship was established by the discovery of annotations in French underneath the paint it was thought to be by a follower of Jan van Eyck, or even Pieter Bruegel. But the unusual composition, in which the figure seems literally to be squeezed into the picture frame, is more typical of Jean Fouquet.

Fire

1566

Giuseppe Arcimboldo

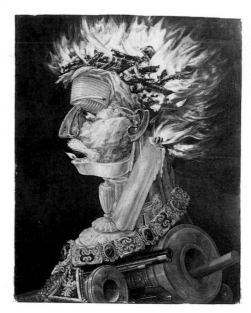

The Italian painter Arcimboldo's fame rests on his bizarre compositions in which vegetables, flowers, fruit or other items are assembled to make human heads. This painting hangs with three others by him, in which Water, Summer and Winter are personified as profile busts composed of appropriate ingredients. They once belonged to two complementary allegorical cycles depicting the elements and the seasons. These were were created for Emperor Maximilian II, for whom Arcimboldo (1527–93) was court painter and master of ceremonies, and they were later incorporated into Emperor Rudolph II's collection. In *Fire*, burning timber, coal, candles, flints and an oil lamp are contrasted with fire of a different sort produced by firearms such as pistols and cannons. The Order of the Golden Fleece around the neck and the Habsburg double-headed eagle below it are tributes to the ruler who commissioned the series.

Lucas Cranach the Elder (1472–1553) was second only to Dürer as the foremost artist in Germany during the Renaissance. From obscure beginnings in Kronach near Coburg he was moving in illustrious scholarly and aristocratic circles by the time he was in his mid twenties, and he even spent some time in Vienna building his artistic reputation. It was probably while he was in the Austrian capital that he met Elector Frederick the Wise, whose service he entered in about 1504; he was to remain court artist to the Electors of Saxony for the next fifty years. Cranach ran a successful studio which produced a huge number of large and highly finished pictures, some of them painted by his two sons who also became artists.

Hunting was a favourite pastime among the members of the royal courts, and it was Cranach's duty to record festive occasions such as these. The stag hunt was a ritual slaughter at which countless stags were chased into the river by dogs and men on horseback so that they were easier to shoot at with crossbows. This picture records a specific event which took place thirty years before it was committed to canvas. Emperor Maximilian and Electors Frederick the Wise and John the Steadfast are shown in the foreground with their keepers, but since both Maximilian and Frederick were dead when the picture was painted, it was probably commissioned by John the Steadfast as a memento. Cranach's choice of a high viewpoint allowed him to show as much incident as possible, sparing no detail of the carnage.

Jane Seymour, Queen of England

1536

Hans Holbein
the Younger

The German artist Hans Holbein the Younger (1497/8–1543) was the greatest northern European portraitist of the Renaissance. He was born in Augsburg and worked in Basel, but in 1526 he left the Continent to live in England where, apart from a brief second period in Switzerland, he remained for the rest of his life. The museum possesses seven of his pictures, all dating from late in his English career. They include likenesses of prominent merchants from the German community in London, courtiers and the King's physician. All are distinguished by a masterly attention to detail and facial expression and a convincing three-dimensionality.

Henry VIII made Holbein court painter in 1536, and this portrait of the King's third wife, Jane Seymour, must have been one of the first commissions he undertook in that official capacity. Jane was only in her mid twenties when it was painted. She had joined Henry's court as a lady-in-waiting to Catherine of Aragon and had also served Anne Boleyn. The King married her in 1536 and she died the following year while giving birth to the future King Edward VI. The separate textures of velvet, brocade and lace are beautifully observed, yet the Queen seems slightly unapproachable. This distant, almost iconic quality was surely intentional on Holbein's part, and fully in keeping with traditions of royal portraiture which emphasized remoteness and grandeur. The life-sized portrait Holbein painted of Henry VIII (now lost) was said to have been so imposing that spectators felt 'abashed and annihilated' in its presence.

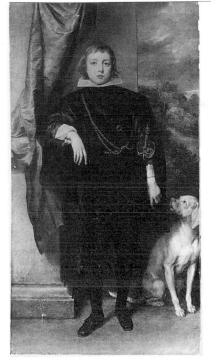

An entire room of the museum is devoted to Sir Anthony van Dyck (1599–1641). Since it is next to the rooms displaying pictures by Rubens, his teacher and collaborator, it is easy for the visitor to see the similarities and dissimilarities between their work. Although Rubens undoubtedly had a powerful influence on Van Dyck, the younger artist's canvases were always marked by a greater sensitivity and nervousness. He achieved fame as a court portraitist in Italy, Flanders and England, with paintings distinguished by their bravura brushwork and excellent characterization.

One of a pair of pendant portraits, this shows Prince Rupert aged about twelve or thirteen. The portrait of his brother Prince Charles, which hangs on the same wall, shows a slightly older youth of about fourteen or fifteen. Their father was the Protestant Elector of the Palatinate and subsequently King Frederick V of Bohemia, who went to live in the Netherlands after he lost his kingdom in the Thirty Years War. It was during this period of exile that Van Dyck painted his sons. Rupert is a solemn-looking boy who adopts the conventional pose often seen in adult court portraits. Dressed from head to toe in black and carrying a sword, he leans against some reassuringly solid architecture while his dog looks up at him. There is a charming vulnerability in the face of the youth who is not yet a man, which combines with the elegance of his stance to produce an impression of nascent aristocratic languor.

The Fur

c. 1635/40

Sir Peter Paul Rubens

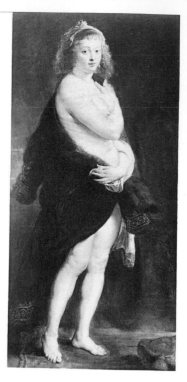

The Rubens collection in the museum is one of the most important in the world. Because Flanders remained in the possession of the Habsburgs up until the eighteenth century and the artist worked as a diplomat and political advisor to the Habsburg governor of the Netherlands, several of his works found their way into Austria. Rubens (1577–1640) was also an extremely influential artist who inspired an entire school of Flemish painters, including Jordaens and Snyders whose works are on show in adjacent rooms. Many of the pictures displayed in the three rooms devoted to Rubens are altarpieces on a monumental scale, such as the *Ildefonso Altar*, ambitious mythological works or political allegories. This picture, however, is private and intensely intimate. Halfway between conventional portrait and mythological representation, it is a celebration of the beauty of the artist's second wife, Hélène Fourment, whom he married when he was in his mid fifties and she was just sixteen. Hélène's pose is that of Venus Pudica, the Classical goddess of Love who was often shown in antique statues in a modest attitude, with her hands lightly covering her breasts and pubic area. It looks as though she has been surprised on her way to bathe, but in her efforts to conceal her nudity by clutching her fur round her body she succeeds only in revealing more of herself and exposing her breasts in an extremely provocative manner. While she stares out at the spectator she also invites admiration in return. It is worth noting that Rubens copied Titian's *Girl in a Fur* which is also displayed in the museum. Separated by exactly a century, the two paintings make an interesting comparison.

Flower in a Vase in front of Parkland

Date unknown

Jan van Huysum

Jan van Huysum (1682–1749) took the long-lived tradition of Dutch flower painting to the peak of perfection in the eighteenth century. He created lavish compositions such as this, in which individual blooms are mixed with living creatures – note the little lizard robbing a bird's nest in the foreground, the butterflies and the incidental insects, together with the drops of water on petals. Yet although he painted the flowers from the life, he sometimes paid little attention to their seasonal compatibility. This composition is pervaded by a marvellous sense of Rococo artifice; roses, delphiniums, morning glories, tulips, bluebells and peonies tumble out of a terracotta urn decorated with cupids, while in the background there is the suggestion of a Classical Arcadia peopled with lovers and statuary.

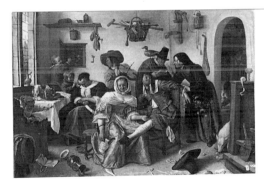

Beware of Luxury

1663

Jan Steen

The Dutch artist Jan Steen (1625/6–79) was an enormously prolific painter who specialized in comic genre scenes. His pictures are crowded with humorous details which usually add up to an illustration of some proverb or moral. Here a slate in the bottom right-hand corner bears the first part of a Dutch inscription, 'At a time of good living, beware', with the implication that retribution will follow. All the chaos of the dissolute household – drunken and lascivious behaviour, food spilt on the floor, the dog eating the pie on the table, the pig rooting around the floor and the negligent housewife asleep at the table – will reap the punishment implied by the crutch and sword in the basket hanging from the ceiling.

Woman Peeling Apples

c. 1661

Gerard Ter Borch

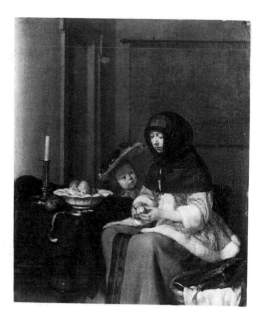

One of the great masters of seventeenth-century Dutch genre painting, Ter Borch (1617–1681) produced canvases of quiet containment and psychological penetration. He seems to have travelled to Rome, London, Germany and possibly Spain before settling in the provincial Dutch town of Deventer, where he spent the rest of his life. Yet his works are far from provincial, being distinguished by an extraordinary refinement and grace, a sensitivity to light effects and a subdued tonality. The tranquillity of this image of a mother engaged in simple homely routine immediately prompts comparison with the work of Vermeer, who also specialized in portraying women absorbed in domestic tasks such as letter-writing, pouring milk or playing the virginals. The care of children and parental responsibility formed another popular theme in Dutch painting of the time, and it is one which Ter Borch invests with a peculiar poignancy as he shows the little girl gazing at her mother in rapt attention, presumably waiting to eat the apple that is being peeled for her. The artist's sister Gesine modelled for the woman. The carpeted table bearing an arrangement of candlestick and apples and the cushion in the workbasket to the right are pleasing reminders of the Dutch love of still life.

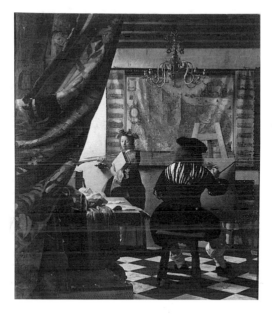

Far from being a naturalistic depiction of a painter at work, this is a complicated allegory on the nature of painting. An artist in rather antiquated costume and seen from the back, is in the act of portraying a model posing as Clio, the Muse of History. Crowned with a laurel wreath, she carries the trumpet of fame and a book which has been identified as Herodotus or Thucydides. On the table are a treatise on painting, a mask and a sketch book, while on the back wall is a map of the seventeen provinces of the Netherlands before they were divided in 1581. The precise meaning of the picture will always be elusive, but it may be that Vermeer (1632–75) intended it to show the Muse of History inspiring the painter or to stand as an allegory of the art of history painting in the Low Countries. The scene could also be read as representing a contest in which painting triumphs over her sister arts of sculpture (the mask) and drawing (the sketch book). It has never been established whether the figure of the artist is a self-portrait, but the late medieval dress he wears would have identified him as an 'Old Master' to a seventeenth-century audience.

The composition has been designed with great care. We are invited in to the picture space past a richly coloured tapestry curtain that is drawn back behind a chair. As in all Vermeer's paintings, the fall of light and shadow is meticulously recorded; dots of paint have been used to suggest highlights on the chandelier and chair buttons.

Large Self-portrait

1652

Rembrandt van Rijn

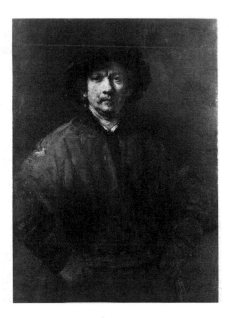

There are many known self-portraits by Rembrandt (1606–69), including sixty-four canvases, twenty etchings and about ten drawings. Something in the order of ten per cent of the artist's total output consisted of images of himself, and since they were produced throughout his career they form a special pictorial autobiography which reflects alterations in his circumstances as well as his changing physique. This is the earlier of the two portraits owned by the museum and was painted the year that Rembrandt's fortunes took a turn for the worse. His financial trouble ended in his bankruptcy around the time that the smaller self-portrait was completed. The artist's pose, which shows him confronting the spectator straight on, his hands hooked in his belt, has a slightly defiant air about it. He is wearing a simple painter's outfit rather than the fanciful and exotic costumes that he tended to adopt in the early self-portraits. Because of the shadowy background and lack of costume detail all attention is drawn to Rembrandt's face, which is softly lit from the left, the highlights built up with thick layers of paint.

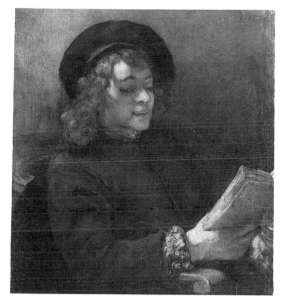

Titus was the only child of Rembrandt's marriage to his first wife Saskia to survive infancy. He was born in 1641 and so would have been about fifteen or sixteen when this portrait was painted. It is one of a series of likenesses that Rembrandt (1606–69) produced of him, which all date from around 1655 to 1660 and allow us to build up a good idea of Titus's physical attributes and character. It is easy to see some family resemblance in the general proportions of the face, the broad nose and wavy hair, and the general impression is of an attractive, good-natured boy. In this canvas he is concentrating upon his book, his lips slightly parted and his eyes cast down on the page. The picture is somewhere between a portrait and a genre piece, since reading was a popular motif in painting at the time. With all detail pared down to the minimum, the picture relies for its effect upon the way the light falls upon Titus's forehead, nose, mouth and hands, bringing them out of the surrounding gloom. Rembrandt's affection for his son is quite evident, and it seems to have been reciprocated. When the artist was declared bankrupt it was Titus and his stepmother Hendrickje who came to his rescue by taking over his art business and claiming that he worked as their employee. Titus predeceased his father, dying the year before Rembrandt at the age of twenty-seven.

The Bravo

C. 1520

Titian (Tiziano Vecellio)

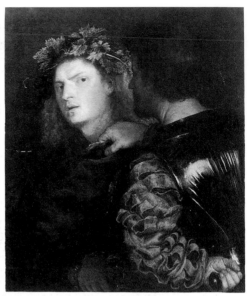

Titian (*c.* 1485–1576) was the most important and celebrated artist in sixteenth-century Venice. The deaths of Giorgione and Bellini in 1510 and 1516 respectively left him without a noteworthy rival in the city and allowed him to dominate artistic life there for the next sixty years. By the 1530s he was famous throughout Europe, receiving commissions from members of the European nobility and ennoblement by Emperor Charles V, one of his greatest patrons.

The Bravo is a work of enormous vigour, but the incident depicted is entirely without context or explanation. *Bravo* was the name of a hired assassin, whom we see emerging from the shadows to assault his intended victim. The composition is extraordinarily dynamic; the spectator's eye is drawn up the left arm of the assassin to his right hand, which clutches the collar of his victim, and then down again to where the youth is just about to draw his sword with his right arm. The drama of the act is heightened by the contrast between the darkness of the hired killer's features and clothing – his red sleeve a reminder of the imminent bloodshed – and the pale skin and hair of the youth he is attacking. Where the *Bravo* wears a hard shiny top that looks like armour, the youth's green jacket is soft and yielding. Similarly, the figure of the *Bravo* is conveyed in harsher, more vigorous sweeps of paint than that of the youth, which is almost reminiscent of Giorgione in its fine and gentle brushstrokes.

Titian (Tiziano Vecellio)

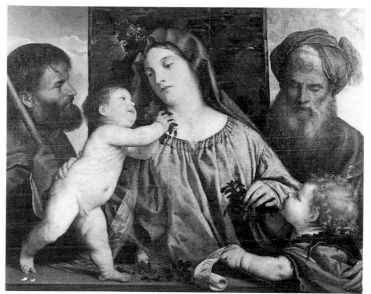

The museum's collection of Titians is extensive, outshone only by that of the Prado in Madrid, and all phases of the artist's career are shown from the earliest to the last. This painting makes an interesting comparison with the artist's slightly earlier Virgin and Child, *The Gypsy Madonna*, which hangs in the same room. Both are set in in the open air with a cloth backdrop placed behind the figures, both show the Christ child standing on a parapet and both employ a pyramidal form of composition. But whereas the earlier picture is static and suffused with the type of golden light one finds in Bellini, with whom Titian trained, this painting is more dynamic. Christ seems to rush up to his mother to present her with a bunch of cherries, and the infant St. John also reaches eagerly up to the Virgin. Cherries, which were considered the fruit of Paradise and given as a reward for virtuous behaviour, symbolize Heaven. There is an interesting interplay of eyes among the figures, who all look at each other and in turn lead the viewer's eye round the picture space. When the painting was transferred from canvas to panel in the last century it was discovered that St. Joseph, the father of Jesus (on the left) and St. Zacharias, the father of St. John (on the right) were later additions to the picture, possibly in order to lend stability to the composition or possibly at the request of the patron.

⭐ Three Philosophers

c. 1508/99

Giorgione (Giorgio da Castelfranco)

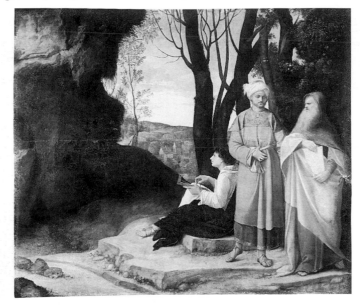

Although only a handful of paintings are accepted as his, Giorgione (c. 1477–1510) had a decisive influence on painting in Venice, where his poetic landscapes and mastery of colour were widely admired. The meaning of this canvas is almost as elusive as the available information about Giorgione's own life, and since it was tailored to the demands of a particular patron and his erudite circle of friends rather than the general public, its theme is likely to remain mysterious. The three men may represent the three ages of man, three different philosophical or mathematical schools, or even the three Magi awaiting the appearance of the star over Bethlehem. Reading the picture from left to right, the progression from youth to age and from darkness to light, as well as the fact that two of the men carry mathematical instruments, tempts speculation that it could represent a progress towards intellectual enlightenment. The softly lit landscape is accorded equal importance with the figures and contributes its own elements to the overall enigma. The nature of the dark rock on the left is ambiguous – one wonders if it could indicate a cave or a state of ignorance – and it is hard to know whether the narrative takes place at sunrise or sunset, although it is intriguing that the the old man on the right is carrying a diagram of the moon. Also hanging in the Kunsthistorisches Museum is *Laura*, Giorgione's only dated painting.

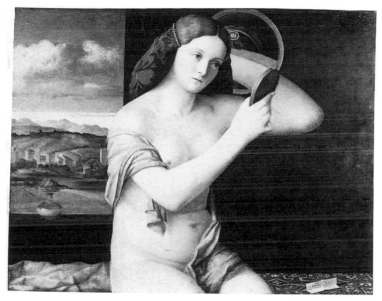

The Venetian artist Giovanni Bellini (*c.* 1433–1516) is generally remembered for his gentle Madonnas, but this is a secular work, and a rare example of a nude painting by him. The panel is a very late one, produced when the artist was in his eighties, and in subject it is related to the erotic themes that were taken up by a younger generation of Venetian painters, particularly Bellini's students Giorgione and Titian. There is a bold abstract quality about the composition. The flat green background on the right gives way to a lovely landscape glimpsed through a window – a division which is echoed in the transition from the Turkish carpet to the soft cloth of the drapery. Interior and exterior worlds are connected by the fact that the colours in the cloth on the woman's head echo those in countryside, and the glass vase on the window sill acts as a link between the two spaces. Although there is a fascinating interplay of figure and reflection in the mirror hanging on the wall, the image in the glass is clearly an impossible one given the angle of the head, and the anatomy of the left arm seems confused. Yet this does not detract from the undeniable charm of the picture, or the calm beauty of the woman's face.

Portrait of a Youth Against a White Curtain

c. 1508

Lorenzo Lotto

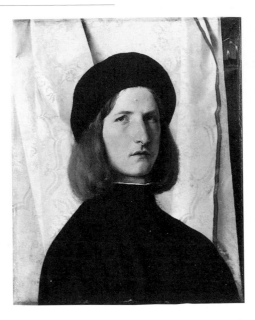

Despite the artist's Venetian origins and the fact that he trained with Giorgione and Titian in Bellini's studio, Lotto's work is not entirely typical of the Venetian school. This early portrait owes a great deal to northern traditions of portraiture in the tautness of outline and the clarity of its surface detail – the wart on the forehead is lovingly delineated – and it may be that Lotto (1480–1556) was inspired by the example of Albrecht Dürer, who was in Venice just before it was painted (see page 80). The identity of the sitter is unknown; he possesses a face that is not classically handsome but distinguished, with its long nose and drooping eyelids. His costume gives little clue as to his status, but the oil lamp visible behind the white damask curtain must surely be a symbolic comment on his personality, although its precise meaning has now been lost. With its juxtaposition of black and white areas relieved by an artfully positioned green border, the picture is a strikingly bold composition which nonetheless manages to convey an impression of a rather melancholy, taciturn individual. It hangs in a room with other remarkable works by the artist, including an intriguing triple-view portrait of a goldsmith and an unusual portrait of a man with an animal paw.

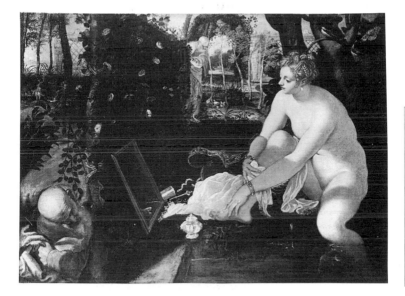

The Old Testament tells the story of Susanna, the wife of a wealthy Jew, who was secretly desired by two elderly men. Following her usual custom, she went to bathe in her garden one day and was surprised by the two men who lay in wait for her near her bower. They threatened that if she did not give herself to them they would publicly proclaim that they had seen her commit adultery with a young man. She refused their advances, but her cries for help went unheeded and she was brought to trial under their false accusation. Her death sentence was only reprieved at the last minute when the prophet Daniel cross-examined the elders and found flaws in their evidence. The subject was favoured by Renaissance artists because it presented the ideal opportunity to portray a female nude.

Tintoretto (1518–94) was the foremost painter in Venice after the death of Titian, and although his use of colour owed something to the older master, his taste for theatrical gesture and chiaroscuro and his deployment of astonishing foreshortening link him with the Mannerists. This picture employs such Mannerist devices as distortion of scale and perspective to create a feeling of unease. The contrast of the victim's pale flesh and beauty with the darkness in which the two ugly old men lurk also contributes to the atmosphere of menace.

Madonna in the Meadow

1505 or 1506

Raphael (Raffaello Sanzio)

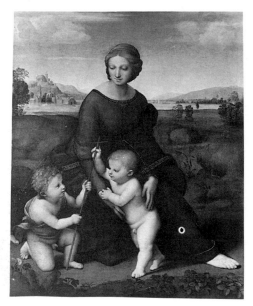

Raphael (1483–1520) is the artist in whose pictures the ideals of the High Renaissance concerning harmony and proportion find their most complete expression. He was born in Urbino into an artistic and cultured family and is said to have trained with Perugino. Although there is no proof of this, a glance at the Peruginos which hang in the same room as this painting certainly lends support to the theory. This Madonna is an early work, dating from the years when Raphael was working in Florence and Tuscany, before he went to Rome to enter the service of Pope Julius II. In Florence he would have encountered the work of Leonardo, and this picture borrows a device seen in Leonardo's Madonna pictures of three figures grouped in a triangle. The Virgin's head, just a little off centre, forms the apex of a pyramid, her right foot one of its corners and St. John the other. The Madonna, whose grace is typical of Raphael, looks on as the infant St. John hands Christ a stick in the shape of the cross to play with – a tragic prefiguration of the Crucifixion. The landscape beyond is divided into two distinct zones: the green foreground in which the figures are situated, with its beautifully observed plants and trees, and the distant blue riverscape, which is pervaded by a dreamy sense of other worldliness. Raphael left the date in the form of the roman numerals M.D.V.I. embroidered in the hem of the Virgin's robe, but since the last figure could be part of the ornamentation, the date may actually be 1505.

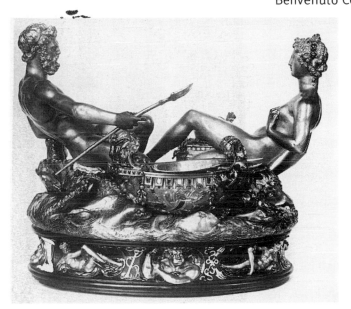

THE KUNSTHISTORISCHES MUSEUM

The Florentine goldsmith and sculptor Cellini (1500–71) left a highly entertaining and marvellously boastful account of his life in his *Autobiography*, which through its tales of frequent quarrels with authority, of imprisonment and of heroic attempts at casting bronze on a large scale went some way towards establishing his posthumous reputation as a romantic hero. He spent the early part of his career in Rome, producing coins and medals for the Popes, and on his second visit to France in 1540–43 the French King François I commissioned him to make a decorative saltcellar. The result was this astonishing masterpiece of Mannerist style, fashioned from gold foil and enriched with enamel. The most important surviving example of the goldsmith's art from the Renaissance, Cellini explained it as an allegory of the unity of sea and earth. The sea-god Neptune holding his trident, surrounded by sea-horses and a boat holding salt, faces the graceful female goddess Ceres, representing the earth. Beside her is a small temple for pepper, and on the ebony base of the piece are allegorical representations of the Four Winds, Morning, Noon, Midnight and Evening. On his return from France Cellini went back to Florence, where he spent the remainder of his life in the service of Cosimo I. There are important examples of his sculpture in the Bargello and the Loggia dei'Lanzi.

Jupiter and Io

c. 1530

Correggio (Antonio Allegri)

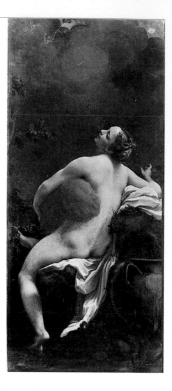

This is one of a series of four paintings illustrating the loves of Jupiter by Correggio (1489–1534), who was active in Parma in the first quarter of the sixteenth century. Ovid's *Metamorphoses* relates how Jupiter, the supreme ruler of the gods, managed to deceive everyone and hide his infidelities from his wife Juno by changing form. Here, he assumes the shape of a cloud in order to seduce the nymph Io. Jupiter's face and right hand are just visible through the grey mist as they enclose Io in an erotic embrace and she falls into swooning submission. The painting's subtlety relies to a great extent on Correggio's mastery of a technique known as *sfumato* – derived from the Italian word for smoke – by which tones are blended softly without lines or borders. The resulting effect of melting sensuality would have greatly appealed to the painting's early owners.

The series was commissioned by Federigo Gonzaga for the Ducal Palace in Mantua, but was later presented to Habsburg Emperor Charles V and taken to Spain. Emperor Rudolph II, who was partial to such subjects, bought the picture from the Spanish in 1601. Another painting in the series, *The Abduction of Ganymede*, which shows Jupiter in the shape of an eagle carrying off a shepherd boy, hangs beside this picture in the museum.

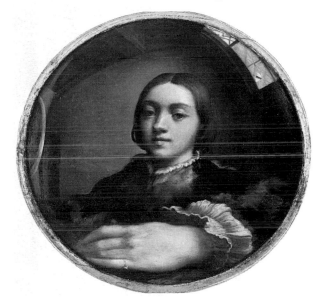

This small circular picture is one of the most appealing curiosities in the museum. It was painted by Parmigianino (1503–40) when he was in his early twenties, just after he had moved from his native Parma to Rome. No doubt he was hoping that its virtuosity would impress Pope Clement VII and win him artistic commissions. The artist was something of a prodigy, having completed two chapels in Parma when he was only nineteen, and a feeling of confidence bordering on arrogance comes through in the portrait. Parmigianino was evidently proud of his angelic features; he is smartly dressed in fur and stares boldly out at the spectator. He paints himself as though seen in a convex mirror, so that the room behind his head curves round while his slender hand protrudes into the foreground to occupy more space than his head. To complete the play on image versus reality, the portrait is actually painted on a piece of convex wood. In its self-conscious wit and contortion, the picture is an example *par excellence* of the Mannerist style, which placed great emphasis on cleverness and exaggeration. This tendency to distortion can also be seen in other works by Parmigianino that hang nearby in the museum. In his *Conversion of St. Paul*, for example, anatomy and perspective are manipulated and deformed in the interest of achieving a tension that evokes the psychological drama of the incident depicted.

1659

Diego Velázquez

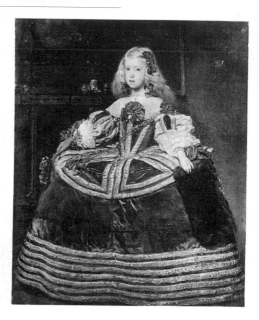

Because of the traditionally close dynastic links between the Spanish and Austrian Habsburgs, the museum has a remarkable set of portraits of the Spanish royal children painted by Velázquez (1599–1660). The Infanta Margarita Theresa was about eight when this likeness of her was produced. While she was still an infant she had been promised in marriage to her Austrian uncle, the future Emperor Leopold I, whom she eventually wed at the age of fifteen; and images of her were sent to Vienna at regular intervals. This portrait hangs near another one showing the princess at the age of three, wearing a pink dress and the same slightly tentative expression. Both pictures are highly formal in arrangement, yet both manage to convey the fragility of the child with her pale, almost transparent skin. The enormous, extensively underwired dress she wears in this picture seems almost to engulf her. The brushwork is admirable for its variety; the dress is rendered with loose and sweeping strokes while the hair and face are delineated with light feathery touches. There is a slightly unfinished feel about the right hand and the background which prompts speculation as to whether the portrait was actually completed; it was done the year before Velázquez died. The artist's lovely portrait of the princess's younger brother Philip Prosper, which hangs on the same wall, was painted in the same year.

Caravaggio (Michelangelo Merisi)

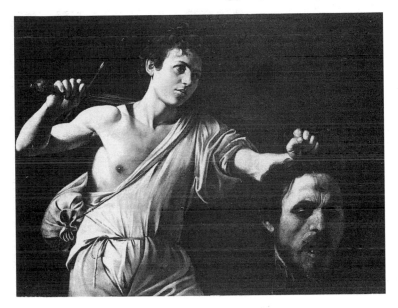

Caravaggio (1571–1610) was one of the most influential painters in seventeenth-century Italy. His turbulent life, which was marked by rows with patrons, acts of violence and even imprisonment, was matched by the energy and unconventionality of his painterly style. He began his career in Rome, and by the time he was in his early thirties he had achieved recognition for his dramatic use of light and shade and for a naturalism which did not shy away from the disturbing or unpleasant. However, at the height of his fame he had to flee from Rome after killing a man during a brawl at a tennis match. Soon after this incident, in 1606, he was in Naples. The two Caravaggios owned by the museum, this picture and the *Madonna of the Rosary*, date from this first stay in that city. The artist produced three major altarpieces there while waiting and hoping that his influential friends would obtain the papal pardon which would allow him to return to Rome; but this was not forthcoming, and he was to spend the remainder of his life in exile.

The brutality of this picture's subject matter is typical of Caravaggio, although David seems a slightly melancholy victor over his opponent. The head of Goliath may be a self-portrait. It certainly resembles a similar Goliath in a previous depiction of the subject which Caravaggio had painted in Rome for Cardinal Borghese.

Built 1330–1414

Address
Salvatorgasse 12
A-1010 Wien
☏ 5332282

Map reference
㉕

How to get there
U-Bahn: U1 or U4 to
Schwedenplatz.
Tram: 1, 2, N.

Opening times
Daily 7–6. Access to all
parts of the church by
appointment only.

Maria am Gestade, with its narrow front (barely ten metres wide but thirty-three metres high) seems to be squeezed into its site along Salvatorgasse. An inspection of the ground plan reveals how the medieval architects had to make the building bend in the middle between the choir and nave in order to follow the line of the street. The church, which is contemporary with the Stephansdom, is home to the town's Czech community. It is a small Gothic gem with an attractive flight of steps leading up to the main entrance, a doorway surmounted by a baldachino, a soaring west front topped by two slender pinnacles and the most extraordinary spire in Vienna, whose open lantern is enlivened with delicate Gothic filigree stonework. Inside, a narrow nave opens out into a light and attractive choir, although it should be remembered that the interior was heavily reconstructed and furnished in the nineteenth century. The stone altar in St. John's Chapel and the fine organ case date from the Renaissance, but in the chapel dedicated to Clemens Maria Hofbauer there are two fine Gothic paintings.

The Neoclassical facade of the Michaelerkirche dominates the eastern side of Michaelerplatz, enlivened by Mattielli's statue of the Archangel Michael trampling on a rebel angel over the west portal and the curious single tower rising beyond. The first church on the site was a Romanesque building constructed by the masons who built the Stephansdom. Traces of this early church can still be seen, notably in the mid thirteenth-century tympanum on the left of the entrance. The choir and the St. Nicholas chapel date from the mid fourteenth century. Further changes in the sixteenth and seventeenth centuries created a remarkably varied interior. Late Romanesque frescoes survive in the tower chapel and the choir arch is adorned with later scenes of the Last Judgement. The most remarkable feature of all is the cascade of stucco angels behind the high altar – a 1782 creation by Karl Georg Merville. Beneath this exuberant splendour sits a sixteenth-century Italo-Byzantine icon of the Virgin Mary. The large organ is a Baroque addition, as is the impressive Trautson memorial by J. E. Fischer von Erlach.

Address
Michaelerplatz
A-1010 Wien
☏ 5338000

Map reference
㉖

How to get there
U-Bahn: U1 or U3 to
Stephansplatz, or U3 to
Herrengasse.

Opening times
Daily 6.30am–6.30pm.

Entrance fee
OS20 for crypt.

Tours
Daily at 11 and 5 except
Sunday to see crypt.

Address
Stubenring 1
A-1010 Wien
☎ 711360
Recorded Information:
7128000

Map reference
㉗

How to get there
U-Bahn: U3 to Stubentor, or
U3 or U4 to
Landstrasse/Wien Mitte.
Tram: 1, 2

Opening times
Tue to Wed, Fri to Sun
10–6; Thur 10–9. 24 & 31
December open 10–3.
Closed 1 January, 1 May,
1 November, 25 December.

Entrance fee
OS90 adults,
OS45 concessions.

Tours
Thurs 7, Sun 11.

The recently renovated Museum für angewandte Kunst (known as MAK) is probably the most user-friendly museum in Vienna. Quite apart from the intrinsic interest of the objects themselves, the displays, designed individually by different artists, are beautifully presented and each part of the collection has its own informative leaflet printed in English and German for visitors to browse through and take away. The building is also a delight. It was built between 1868 and 1871 by Heinrich Ferstel and features an arcaded vestibule off which the display rooms radiate. The permanent collection is shown in this part of the museum and the special study collections are housed in the basement; while temporary exhibitions are put on in the newer annexe. The MAK café (actually a fairly smart restaurant), the book shop and the design shop are added inducements to linger.

When it was first founded in 1864 the museum was intended to have an educational role, to stimulate aesthetic sensibilities and promote creative activity by exposing the public to works of art from the past. It was also to act as a design resource and stimulus to industry, and as though to encourage the links between art and manufacture, a School of Applied Arts to train young artisans was set up as a sister institution. From the start the museum's brief was to assemble the best of Austrian applied arts and manufactured goods, and the first acquisitions were producer's bequests, patterns and specimen collections. However, because it was gathered together from a variety of sources, the collection grew to be far more eclectic than was originally intended, and it now includes such non-Austrian items as Oriental rugs and Far Eastern figurines. The department of contemporary art established in 1986 features three-dimensional works, installations and architectural models.

Brilliant cobalt blue walls set off a variety of objects made in Europe from the thirteenth to the sixteenth centuries, when Romanesque and Gothic styles were giving way to Renaissance decoration. For conservation reasons, the fragile items are protected by glass cases, but these work well in the context of the room and allow the objects to be seen in the round. Outstanding among the exhibits are the delicately coloured liturgical vestments from the Benedictine monastery of Göss in Styria, the only surviving ensemble of church robes from such an early period (c. 1260). They were embroidered by Kunigunde, Abbess of the convent from 1239 to 1269, and her canonnesses, following designs which had first been painted on the fabric with ink. The chasuble and cope would have been worn by a priest, while the deacons and sub-deacons were robed in the dalmatic and tunic.

There are also some interesting pieces of furniture. These include a pearwood folding stool with animal head finials, which came from the Benedictine Abbey of Admont; a sixteenth-century inlaid cabinet with secret drawers from Augsburg, with decoration which shows an awareness of the latest fashion in Italian Renaissance ornament; and a painted table leaf from Swabia. The colourful display of Italian majolica features jugs, pharmacists' vessels, bottles, basins, dishes and plates all adorned with mythological scenes in characteristic ochres, blues and greens.

The Baroque, Rococo and Classicism Collection

Two rooms house the museum's seventeenth- and eighteenth-century items and furniture. The first is the impressive white hall extending over two storeys, which features an extraordinary centrally placed room-within-a-room. This is a reconstruction of an eighteenth-century porcelain cabinet from the Dubsky Palace in Brno, its wood panelling inlaid with porcelain plaques made in Vienna and shelves for vases. Along the perimeter of the grand gallery are choice pieces of furniture placed symmetrically, usually in pairs opposite each other. Most of the items come from Austria, Germany and France. Among them are a bureau cabinet by Roentgen with an interior mechanism that releases a lectern, a coin box and a flute-playing music box; an unusual Czech cabinet with ebony veneer and relief marquetry, on which the drawer fronts bear allegorical representations and portrait medallions of the kings and emperors of the house of Habsburg; Parisian chests of drawers; and a Viennese library table which once belonged to the Vienna Jesuit college. On one wall there is a large framed panel of hand-painted Chinese wallpaper and on another hang a pair of double doors designed for a Viennese palace.

Lace and glass from the Baroque period are shown together in a smaller room, their delicacy and virtuosity of craftsmanship providing a complementary visual effect. Even during the era when it was made, Venetian glasswork was highly valued, and fashionable men and women were prepared to spend vast sums on lace to adorn their costumes.

The museum's Oriental collections are divided into two parts. On the ground floor there are carpets and tiles from the near East, India and Persia (illustrated above), while items from the Far East are exhibited in the basement. In both rooms the display is pared back and minimal, with little to distract from the objects themselves. The carpets, which were the most important decorative element in the Eastern interior, were designed to be admired for the inventiveness and dexterity of their makers. They are displayed on both horizontal and vertical surfaces. The emphasis is on rugs from the sixteenth and seventeenth centuries, and many of the items in the collection, which is one of the finest in the world, once belonged to the Imperial family. One such example is the silk Mameluke carpet produced in Cairo at the beginning of the sixteenth century – the only one of its kind known to have survived.

An atmosphere of stillness prevails in the Far Eastern collection below stairs, where numerous statues of the praying Buddha or Boddhisatva displayed on low-level platforms in the centre of the room raise their hands in benediction to the visitor. All the objects shown here were chosen by Europeans, and so reflect to some degree Western preferences in Oriental art. In return, it is interesting to see the ways in which Oriental designs have affected the type of European design shown upstairs. In softly lit display cases around the edges of the room are porcelain, lacquer ware and glazed or wooden statuettes.

Empire Style and Biedermeier Collections

The effects of the industrial revolution and the growth of middle-class spending power in the first half of the nineteenth century created demand for a wider variety of furnishings and household objects, ranging from expensive luxury items to cheaper versions of the same thing. If the desks and tables in cherry-wood veneer have a surprisingly modern look about them this is because later designers such as Adolf Loos drew their inspiration from the clean lines and exotic woods that were used for this type of furniture. Particularly exquisite are the porcelain cups and saucers from the Viennese Porcelain Manufactory, featuring views of the city or botanical illustrations, and the glass tumblers with enamel decoration and gilding.

Standing in a line across the vast room where many of these items are shown is a succession of chairs, demonstrating succinctly the number of individual variations that could be achieved on the same theme. The backlit display of bentwood chairs by the Viennese firm of Thonet, shown in silhouette in the neighbouring room, achieves much the same effect. A magnificent red sofa of *c.* 1825 has been wittily duplicated in aluminium by the artist who designed the installation, to provide the weary visitor with a place to rest and read the electronic captions carrying information about the Biedermeier era which are flashed up around the top of the room at cornice level.

On the first floor a long room, subdivided by two smaller glass rooms and a hanging glass shelf, contains objects and furniture in the style for which Vienna is most famous. The furniture is by the well-known figures of the Secessionist movement: there is a glass cabinet by Otto Wagner, oddly elongated wall shelves by Josef Hoffmann, a sliding table by Kolomon Moser and items by Dagobert Peche and Eduard Josef Wimmer-Wisgrill. There are also more recent pieces from the Art Deco era by Franz Singer and Rosa Krenn, who is represented by an unusual inlaid cupboard using zebrawood. Klimt's nine large sketches for the Palais Stoclet mosaic frieze, which was executed by the Wiener Werkstätte, are shown along one of the cardboard partitions enclosing the staircase up to the Contemporary Art Gallery. On the parallel wall hangs Margaret Macdonald's gesso frieze illustrating Maeterlinck's play *The Seven Princesses*. This was intended for the Waerndorfer House designed by her husband Charles Rennie Mackintosh. Coloured glass objects by the Wiener Werkstätte and various Bohemian glassworks are shown at eye level in cases suspended from the ceiling

In the neighbouring room the rest of the items produced by the Wiener Werkstätte and owned by the museum are shown almost in their entirety. These are mainly small and exquisite objects such as jewellery and metalwork, leather visiting card cases, handbags and bookbindings. On the glass doors of the cabinets containing the firm's archives are fashion sketches by its designers.

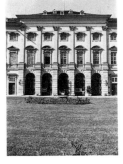

Address
Gartenpalais Liechtenstein
Fürstengasse 1
A-1090 Wien
© 3176900

Map reference
(28)

How to get there
TRAM: D.
BUS: 40A.

Opening times
Tue to Sun 10–6.

Entrance fee
OS45, or OS60 if bought in
combination with entry to
Museum of the Twentieth
Century in Schweitzer
Garden.

Tours
Sat at 3, Sun at 11. During
July and August tours only
on Sun.

This lovely Baroque palace was built at the turn of the eighteenth century by Domenico Martinelli to provide a summer residence for Prince Johann Adam Liechtenstein. Its imposing Marble Hall and ceiling frescoes by artists such as Johann Michael Rottmayr and Andrea Pozzo are still intact, but the walls in most of the rooms have been whitewashed to provide a background for the exhibits of the Museum of Modern Art. Tea, coffee and cakes are served in the impressive ground floor vestibule, or in the garden on sunny days. The first floor is used for temporary exhibitions, and the second floor is given over to the permanent collection of European and American art from 1900 onwards, most of which has been supplied on permanent loan by the Ludwig Foundation. While there are examples of every movement in modern art, they tend to be minor but interesting pieces of work by major artists. There are pictures by the Cubists, Futurists, Surrealists and Purists, as well as New Realists and Pop artists. Among the most pleasing sections is that devoted to the German Expressionists, with paintings by Kirchner, Jawlensky and Schmidt-Rottluff. There are also some fine sculptures by Ernst Barlach, Brancusi, Lipchitz, Duchamp-Villon, André Derain and Medardo Rosso. Developments in Austrian Art are shown in parallel with the European mainstream. The collection will eventually move to a new home when development in the Museums Quartier is completed.

An annexe of the collection is in the Twentieth-century Museum, a rather ugly former pavilion from the 1958 Brussels World Fair, near the Südbahnhof. Exhibitions of contemporary art are shown here, and there is a sculpture garden containing pieces by Arp, Giacometti, Wotruba and Moore.

As one of the collections housed in the Neue Burg wing of the Hofburg complex, the Ethnography Museum has an appropriately grand setting and a splendid marble entrance hall. The magnificence of the building is not always matched by the standard of display, which in one or two areas of the ground floor appears a little dusty and old-fashioned. However, in other rooms, particularly on the first floor, the objects are beautifully shown. The core of the large collection was formed over centuries by the Habsburgs or by ethnologists working for the Austrian government, but today the Museum of Ethnography is an independent research, documentation and education institution of international repute. It covers the society, customs and art of all non-European cultures, and the space is divided between the permanent collection and major loan exhibitions.

On the ground floor are the collections of African bronzes, textiles, weapons, masks and sculptures which provided important inspiration for many European artists working in the early twentieth century, Picasso and Braque among them. Next to these are the Japanese displays, with items from the tea ceremony, everyday objects such as cooking utensils, lacquered boxes, kimonos and musical instruments. There are also sections on Shinto and Buddhism as well as some lovely Korean ceramics. Upstairs is a dramatic presentation of early Mexican sculpture, codices and jewellery, in which pride of place is given to the feathered headdress said to have belonged to the Aztec Emperor Montezuma II and sent by Cortés to Emperor Charles V. Despite the Mexican government's request for its return, there is no sign of it disappearing from the museum as yet. Also on show are the South American Indian objects that Johann Naterer gathered together in the last century and Captain Cook's collection from Oceania.

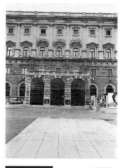

Address
Neue Burg,
Heldenplatz
A-1010 Wien
✆ 52177404

Map reference
㉙

How to get there
U-Bahn: U2 to
Mariahilferstrasse, or U2 or
U3 to Volkstheater.
Tram: 1, 2, J.

Opening times
Tues, Wed, Fri, Sat, Sun
10–6, Thur 10–9.

Entrance fee
ÖS45 adults,
ÖS30 concessions.

Tours
Weekdays 10.15,
Sun 10 and 11.

✪ ÖSTERREICHISCHES MUSEUM FÜR VOLKSKUNDE

(THE AUSTRIAN FOLK ART MUSEUM)

Address
Gartenpalais Schönborn
Laudongasse 15–19
A-1080 Wien
✆ 438905

Map reference
(30)

How to get there
TRAM: 5, 43, 44.

Opening times
Tue to Fri 9–5, Sat 9–12,
Sun 9–1. Closed public
holidays.

Entrance fee
OS45 adults, OS30
concessions, OS75 family
tickets.

Tours
Sunday 10.30, also as listed
in the monthly programme
of Austrian State Museums
or by prior arrangement.

This is the museum to visit when you need a break from the high seriousness of the Old Masters in the Kunsthistorisches Museum or the ornate stucco of Vienna's churches. The displays in the newly renovated folk art museum tell the story of traditional life through the everyday items and works of art produced not by professional artists but by the Austrian people themselves. Exhibits from the seventeenth to the nineteenth centuries are placed in their ordinary context, but one never loses sight of the fact that they are an expression of natural creativity.

There is furniture of all descriptions, including painted wardrobes decorated with naive religious scenes, birds and flowers, and two complete wooden panelled rooms, together with models of rural dwellings, beautifully carved butter stampers, decorative ironwork and scythe cases with carved animal heads. A model of a fantasy town that took its maker decades to create is full of ingenious touches and meticulously observed detail, as is the carved chess set specially made to commemorate the golden wedding of a local aristocrat. There are items connected with hunting; carved sledges; painted ceramics; costumes and feather hats; toys and home-made automata. A ceramic stove in the shape of a full-size peasant woman encapsulates a charming spirit of playfulness, while votive paintings record thanksgiving for recovery from illness or accident, and folk paintings illustrating biblical themes pay tribute to religious devotion. The museum café offers a pleasant place to relax, and there is outdoor seating in the garden during summer. It is worth pausing to admire the facade of the museum, which is housed in the former Schönborn Palace (1706–11). The architect was J. L. von Hildebrandt, who also designed the Belvedere (page 27).

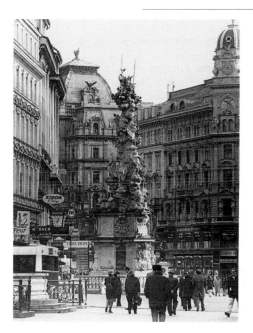

The centre of Graben – an elegant pedestrianized shopping street – is dominated by the Pestsäule, or Plague Pillar, commissioned in 1679 by Emperor Leopold I in thanksgiving for the end of a particularly virulent plague epidemic. It is dedicated to the Holy Trinity and Nine Choirs of Angels. The present column, made from Salzburg marble, was completed in 1693; it replaced an earlier wooden version erected the year the plague ended. From a pyramidal base a twisting column encrusted with clouds and angels rises up to a gilded Trinity group. The praying Emperor Leopold sculpted by Paul Strudel can be seen on the south flank, and the nearby group showing Faith Vanquishing the Plague is also noteworthy. Lodovico Burnacini supplied the design for the obelisk, and Johann Bernard Fischer von Erlach (who was responsible for the Karlskirche – page 62) designed the plinth reliefs according to a complex symbolic programme worked out by the Jesuits.

Address
Graben
A-1010 Wien

Map reference
③①

How to get there
U-BAHN: U1 or U3 to
Stephansplatz.

(ST. PETER'S CHURCH)

Begun 1702

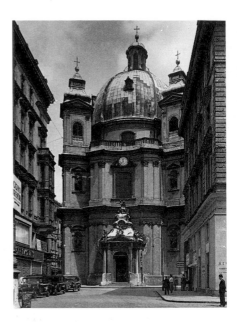

Address
Petersplatz 6
A-1010 Wien
�’ 5336433

Map reference
㉜

How to get there
U-Bahn: U1 or U3 to
Stephansplatz.
Tram: 1, 2, D.

Opening times
Daily 7–6.30. Mass is
celebrated daily at 11 and 5.

Set back from the Graben in its own small square is the Peterskirche. The present building was begun in 1702 according to plans by Gabriele Montani and worked on from 1703 to 1708 by Johann Lukas von Hildebrandt, although it was not finished until later. The copper cupola was put on in 1722; the two towers were added in the 1730s; and the central portal, decorated with allegorical figures of Faith, Hope and Charity, followed in the 1750s. The church is based on an elliptical ground plan, above which is an oval dome decorated with frescoes by Johann Michael Rottmayr depicting the Assumption and a heavenly assembly of apostles, martyrs and saints. A second false dome above the choir was painted with *trompe l'oeil* architecture by the theatre painter Antonio Galli-Bibiena. Lorenzo Mattieli provided the exuberant gilded wooden sculpture of *The Fall of St. John Nepomuk into the Moldau* which complements the ornate pulpit by Matthias Steinl. The side chapels contain further altarpieces by Altomonte and Rottmayr, and St. Benedict in a glass coffin may be seen in St. Michael's chapel.

The German Order of Teutonic Knights was founded in 1190 to look after the poor and ill. Duke Leopold VI invited the Order to set up a base in Vienna in 1205 and gave them the site to the east of the Stephansdom, where the complex of buildings known as the Deutschordenshaus is arranged around two pleasant courtyards. When Napoleon dissolved the Order in Germany in 1809, Vienna became the headquarters of the Teutonic Knights, and the treasure amassed over centuries by the Knights and Grand Masters was moved to this site, where it is now housed in five rooms on the second floor. Visitors enter the building through a covered alley, passing the narrow Deutschordenskirche on the right. It is worth pausing for a moment to admire the church, which has a pretty Gothic vaulted interior and two lovely altarpieces (one Gothic and one Baroque), coats of arms and banners.

The collection in the treasury is a fairly small one, but contains some rare and unusual items displayed in a straightforward and sympathetic manner. The first room you come to contains coins, medals, seals and statute books of the Order, and this leads into the second, where silver and gold tableware and a chocolate set made from coconut shells and Chinese lacquer are shown alongside Mass vessels. Perhaps the most unusual object is the 'viper's tongue credence' used for testing food for poison. Room three is devoted to the collection of Maximilian I, who was at one time Grand Master of the Order and, like his brother Emperor Rudolph II, an ambitious art collector. It contains a number of small and precious items of the type traditionally found in a *Kunstkammer*, including a splendid clock and an astrolabe. The last two rooms house costumes and uniforms of the Order; glassware; an outstanding filigree banqueting dish made in southern Germany; an eighth-century golden cross; a thirteenth-century gold bird with enamel inlay and various monstrances and reliquaries.

Address
Singerstrasse 7
A-1010 Wien
℡ 51210656

Map reference
③③

How to get there
U-Bahn: U1 or U3 to Stephansplatz.

Opening times
May to October: Mon, Thur and Sun 10–12; Wed 3–5; Fri and Sat 10–12, 3–5; November to April: Mon and Thur 10–12; Wed and Fri 3–5; Sat 10–12, 3–5.

Entrance fee
OS25 adults, OS15 students, children under 10 free.

Tours
Available by prior arrangement.

Built 1695–1743

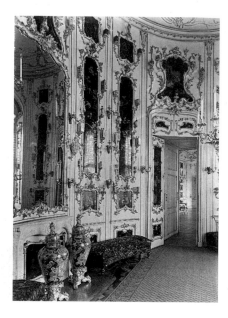

Address
Schönbrunner Schloss
Strasse 47
A-1130 Wien
✆ 811130

Map reference
㉞

How to get there
U-BAHN: U4 to Schönbrunn.
TRAM: 10, 58. BUS: 15A.

Opening times
State rooms: April to
October: daily 8.30–5;
November to March: daily
8.30–4.30.
Wagenburg (Coach
Museum): daily 9–6.30.

After the hunting lodge of Katterburg on the edge of Vienna Woods was destroyed during the Turkish seige of 1683, Emperor Leopold I commissioned Johann Bernard Fischer von Erlach to build him a new summer palace. The architect initially planned a palace on top of the hill where the Gloriette now stands that was to rival Versailles in grandeur, but he had to scale down his ambitions in favour of the present building, positioned at the foot of the slope. Nonetheless, with over 1400 rooms and apartments, the palace is hardly modest. Unfinished at Fischer von Erlach's death, it was completed and adapted by Maria Theresia's favourite architect, Nikolaus Pacassi, who was largely responsible for the sumptuous Rococo interiors occupied by the Empress and the delightful theatre in the courtyard. A visit to the state apartments reveals a succession of rooms in which white and gold predominate. Among the most breathtaking are the Vieux-Lacque Room, with its Oriental lacquered panels, and the Million Room, lined with Indian and Persian miniatures.

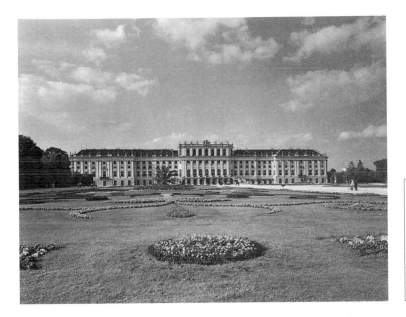

The symmetry of Schloss Schönbrunn is complemented by its formal gardens with parterres, clipped yew hedges, sculptures, follies and fountains. These were initially laid out in the French style by Jean Trehet of Paris, but were later altered by the Dutch landscape gardener Adrian van Steckhoven and by Ferdinand von Hohenburg, who also added a number of the architectural features. A central axis leads from the garden front of the palace past a series of formal parterres to the Neptune Fountain. This exuberant piece, showing Neptune and Thetis amid tritons and nymphs, was built in 1780. From here, a zig-zag path winds up a slope to the Gloriette, an enormous loggia with a triumphal gate surmounted by an eagle, which was created by Hohenburg in 1775. Below this, to the right, are a delightful circular zoo, with a small pavilion (now a café) where the Imperial family once took breakfast while watching the antics of the animals, and a magnificent palm house. The park is freely open to the public until sunset every day.

On either side of the parterres are a number of avenues or 'boskets': tree-lined walks following a strictly geometric ground plan which inevitably end in a view of a statue or building. The most famous of these landmarks is the Romantic fake Roman ruins added in 1778, complete with Corinthian columns and statues of river gods. Open air opera performances are held here every summer. Nearby is a grotto on the site of the 'Schöner Brunnen' or beautiful fountain, which gave its name to the palace complex. The former winter riding school has been transformed into a Coach Museum, which houses the fabulous carriages once used by the Habsburgs.

Built 1898

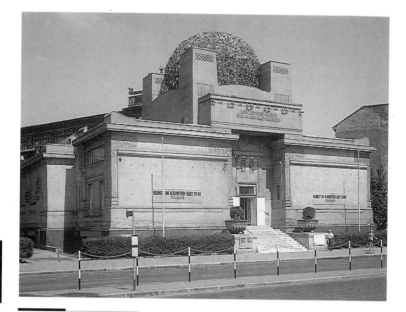

SECESSION

Address

Friedrichstrasse 12
A-1010 Wien
℡ 5875307

Map reference
㉟

How to get there

U-Bahn: U1, U2 or U4 to
Karlsplatz.
Tram: 1, 2, D, J.

Opening times

Tue to Fri 10–6; Sat, Sun
and public holidays 10–4.
Closed Mon.

Entrance fee

OS60 adults,
OS30 students.

After the group of avant-garde Viennese artists led by Gustav Klimt had broken away from the Kunstlerhaus in 1897, their most pressing need was for an exhibition space. Joseph Maria Olbrich, a founding member of the group, immediately set to work to design one of Vienna's most distinctive and surprising buildings. The result was the Secession, named after the group of rebel artists. A filigree gilded dome – which earned it the nickname 'golden cabbage' from stallholders on the nearby vegetable market – sits on top of a white cube, whose severity is relieved by pleasing details such as the frieze of Medusa heads above the door and the golden tracery of leaves at the corners. The Secessionists' motto '*Der Zeit ihre Kunst, der Kunst ihre Freiheit*' (To the Age its Art, to Art its Freedom) is proudly emblazoned above the entrance. The ground floor hall is used for temporary exhibitions of modern art. The *Beethoven Frieze* by Klimt is permanently on display downstairs in the room it originally occupied.

1902

Gustav Klimt

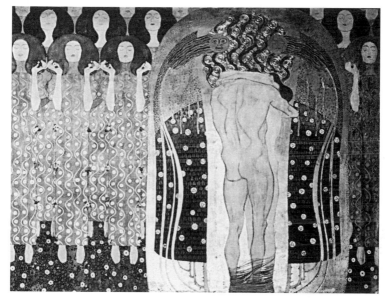

The fourteenth Secessionist exhibition in 1902 was organized around Max Klinger's massive monument to Beethoven. To complement the statue, which presented the composer in appropriately heroic mode, Klimt created a fresco inspired by the Ninth Symphony. This has recently been restored and is shown in its original setting. Based upon Richard Wagner's interpretation of the piece, Klimt's painting narrates humanity's passage from sickness, debased lust and madness to the attainment of true love. Reflecting the form of a symphony, the work progresses through three major episodes, with the forms and colour in the sequence beginning quietly, then passing through a more strident phase before dying down again in anticipation of the final great harmonious crescendo. On the long wall facing the entrance, the weak implore the strong (represented by a knight in armour) to intervene on their behalf against the Hostile Powers (symbolized on the narrow wall by Typhon the Giant and his daughters the three Gorgons, together with the figures of Debauchery, Unchastity and Excess). The flying figures above them represent the longings of humanity, which reaches towards Poetry (personified as a woman playing the lyre) for solace: the implication is that the arts lead human beings to a kingdom where they can find pure happiness and love. The scheme finds its resolution in the couple embracing against the background of a heavenly choir, encapsulating the phrase in Schiller's 'Ode to Joy' which is sung in the Ninth Symphony: *Diesen Kuss der ganzen Welt* (This kiss to all the world).

✪ STEPHANSDOM

Built 1230–c.1578

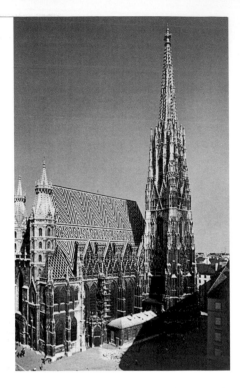

Address
Stephansplatz 3
A-1010 Wien
✆ 51552530

Map reference
㊱

How to get there
U-BAHN: U1 or U3 to
Stephansplatz.

Opening times
Daily 7am–10pm.

Entrance fee
OS20 South Tower, OS40
elevator to North Tower,
OS35 catacombs.
Catacombs may only be
seen with tour.

The Stephansdom is literally and metaphorically the heart of Vienna. Standing in its own square in the centre of the inner city, its 137-metre steeple (known as the 'Steffl' or little Stephen) dominates the skyline from miles around. The original Romanesque church consecrated in 1147 was replaced in the thirteenth century with a late Romanesque building, of which the only remains are the massive main entrance gate and two flanking 'Heathen' towers. The bulk of the church was constructed in the Gothic style in the fifteenth century, but the curiously truncated northern tower, which was begun in 1450 but never completed, was not capped until the end of the sixteenth. Apart from the spire with its filigree decoration, the cathedral's most extraordinary external feature is its tiled roof. This is actually a modern reconstruction since the original roof was destroyed by bombs during World War Two. Inside the lofty bare stone nave, Gothic sculptures under canopies decorate the pilasters, while Baroque side altars cling to their bases. The main altar of black marble was built in 1647.

The most important Gothic work of art in the nave of the cathedral, this splendid pulpit was carved by Master Anton Pilgram (1450/60–c. 1515), who left his own portrait on its base in the shape of a man peeping through a window. This is one of two self-portraits by the master stone-carver; the other, on the corbel of the empty organ case on the nearby wall, is painted and shows him holding the tools of his trade. The portrait on the corbel is initialled and dated 1513, and since it shows an older man the pulpit can be assumed to date from around the turn of the sixteenth century. Sculpted from only four blocks, the staircase leading up to the pulpit sweeps round the pilasters with seemingly effortless grace; on its hand rail is a rather unexpected procession of sculpted reptiles. The pulpit itself is supported on a slender stem surrounded by small sculptures below delicate Gothic canopies; above these, keel-shaped Gothic arches billow outwards and upwards to meet the pulpit itself, which is decorated with busts representing the Four Fathers of the Church: St. Ambrose, St. Jerome, St. Augustine and St. Gregory the Great. These four saints were traditionally seen as representing the four temperaments: St. Augustine the melancholic, St. Jerome the choleric, St. Ambrose the sanguine and St. Gregory the phlegmatic. Pilgram has captured the typical expressions of these four types with great vivacity.

The Wiener Neustadter Altar

1447

In the north side of the nave, to the left of the main altar, is this large fifteenth-century carved and painted altarpiece. It was made by an unknown craftsman for the monastery at Wiener Neustadt and consists of four panels, a predella or base, and a carved interior. Because of the movable wings there are three possible presentations, and what you see may depend upon when you visit. The closed or daily side shows a number of saints against a dark background, whereas in the first opened state, traditionally shown on Sundays, similar portraits of saints are set against a gold background. In all, seventy-two holy figures are depicted, some of them identified by inscriptions. Although the arrangement is absolutely regular, with the saints set out in four rows, three to a panel, the variety of movement and dress creates a varied effect. The interior of the altarpiece, also opened on Sundays and particular festivals, is probably the most spectacular. It contains a number of polychrome figure groups: in the centre at the bottom is a representation of the Madonna and Child flanked by St. Barbara and St. Catherine; above them is the Coronation of the Virgin. The left panel contains another Coronation of the Virgin and the Birth of Christ, while the right one shows the Death of the Virgin and the Adoration of the Magi. The sculptures were all carved around the second and third decades of the fifteenth century. This part of the cathedral is not always open to individual visitors and can sometimes only be seen on a guided tour, so it is worth checking beforehand.

ACKNOWLEDGEMENTS

The author and publisher would like to thank the following Viennese museums and galleries, individuals and photographic archives for their kind permission to reproduce the following illustrations:

Kunsthistorisches Museum: 6, 7, 11 l, 71, 72, 73, 74, 75, 76a, 76b (AKG, London), 77, 78 l&r, 79, 80, 81, 82, 83, 84, 85, 86, 87 a&b, 88, 89, 90, 91, 92, 93, 94, 95, 96, 97, 98, 99, 100, 101, 102, 103

Angelo Hornak, London: 9, 10r, 14b l&r, 15 l, 25, 47, 51, 60, 61, 63, 64, 65, 68, 69, 115, 117, 120, 123, 124

Fotostudio Otto: 10 l, 56, 104, 122

Gemäldegalerie der Akademie der bildenden Künste: 11r, 19, 20, 21, 22, 23

Österreichische Galerie Belvedere (Fotostudio Otto): 12, 14a, 16 a&b, 26, 27, 28, 29, 31, 32, 33 a&b, 36, 37, 38, 39, 40, 41, 42, 43, 44 (© Dacs, 1995), 45, 46

Historisches Museum der Stadt Wien: 13 (E. T. Archive, London), 53, 54, 55

Kunsthaus Wien (Hundertwasser Archives, Joram Harel): 15 r

Simon Bell, London: 18, 24, 30, 48, 49, 50, 52, 66, 70, 105, 106, 112, 113, 114

A. F. Kersting, London: 34, 35, 62, 67, 116, 118, 119

The Hofburg: 57, 59 (Burghauptmannschaft in Wien), 58 (Kunsthistorisches Museum)

Österreichische Museum für angewandte Kunst (Gerald Zugmann): 107, 108, 109, 110, 111

Secession (AKG, London): 121

The author would also like to thank Christian and Elisabeth Goldstern, Brigitte Mauthner, Simon Bell, Julia Brown and Christine O'Brien for their assistance.

Index of Artists, Sculptors and Architects
Figures in bold refer to main entries

INDEX

ITINERARIES

A note on the itineraries

The following itineraries are designed for those with a week to spend in Vienna. The suggested combinations for each day have been governed by practical concerns, such as location and ease of travel between the attractions. In some cases it may simply be a question of walking from one side of a square to another. It should be possible to view everything suggested on each day's itinerary, but visitors may well choose to proceed at a more leisurely pace and concentrate on one or two locations and exclude others. Those with limited time should focus on the starred items. Works of art are listed in the order that they are most likely to be seen within each museum, church or gallery. The numbers in circles beside each location are map references.

The Geymüller-Schlössel (p. 51), the Kirche am Steinhof (p. 63) and Klosterneuburg Abbey (p. 64) are all at a reasonable distance from central Vienna. However, because it takes slightly longer to travel to them, it is suggested that visitors choose to visit one of these on the afternoon of Day 7 as an alternative to the attractions on the itinerary. Although the Kirche am Steinhof is generally open to the public only between 3 and 5 on Saturday, appointments can be made to view the interior at other times. The Geymüller-Schlössel is closed from 1 December to the end of February.

Several attractions are closed on certain days in the week. The itineraries have been designed to take this into account, provided that Day 1 is regarded as a Saturday and therefore Day 3 is a Monday.

The entry fees and opening times are correct at the time of publication, although they may be liable to change without notice.

DAY 1 (SATURDAY) MORNING

✪ THE KUNSTHISTORISCHES MUSEUM ㉔ (p.67)

Collections of Dutch, Flemish and German Painting
Spring Landscape (May)
Lucas van Valckenborch (p.72)
✪ Hunters in the Snow
Pieter Bruegel the Elder (p.73)
The Peasant Wedding
Pieter Bruegel the Elder (p.74)
The Crucifixion
Rogier van der Weyden (p.75)
Christ Carrying the Cross
Hieronymus Bosch (p.76)
The Altarpiece of the Archangel Michael
Gerard David (p.76)
The Fate of the Earthly Remains of St. John the Baptist
Geertgen tot Sint Jans (p.77)
The Fall of Man and the Lamentation
Hugo van der Goes (p.78)
Adoration of the Trinity (The Landauer Altar)
Albrecht Dürer (p.79)
Portrait of a Young Venetian Lady
Albrecht Dürer (p.80)
The Court Jester Gonella
Jean Fouquet (p.81)
Fire
Giuseppe Arcimboldo (p.82)
Stag Hunt of Elector Frederick the Wise
Lucas Cranach the Elder (p.83)
Jane Seymour, Queen of England
Hans Holbein the Younger (p.84)
Prince Rupert of the Palatinate
Sir Anthony van Dyck (p.85)
The Fur
Sir Peter Paul Rubens (p.86)
Flowers in a Vase in front of Parkland
Jan van Huysum (p.87)
Beware of Luxury
Jan Steen (p.87)
Woman Peeling Apples
Gerard Ter Borch (p.88)
✪ The Artist's Studio
Jan Vermeer (p.89)